MW01077990

FINDING BALANCE

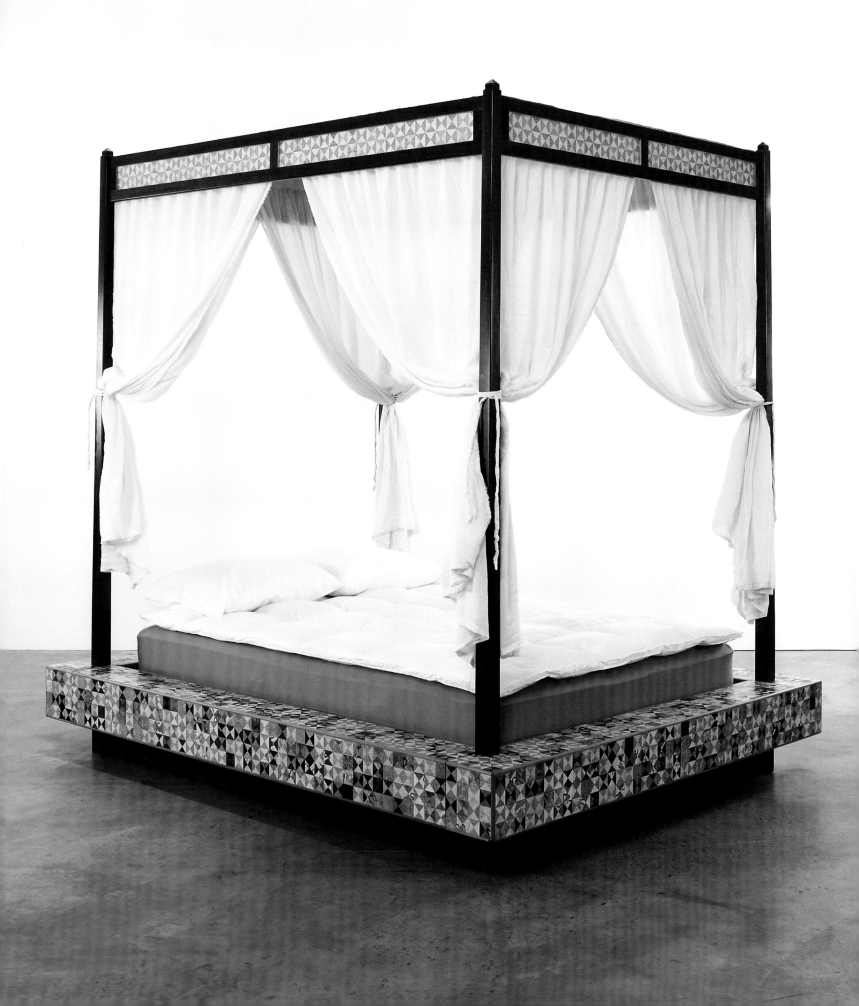

FINDING BALANCE

*Reconciling the Masculine/Feminine
in Contemporary Art and Culture*

Introduction

Charmaine Locke

Essays

Leonard Shlain

James Surls

Distributed by

University of Texas Press

HOUSTON CENTER FOR CONTEMPORARY CRAFT

This book accompanies the exhibition
Finding Balance: Reconciling the Masculine/Feminine in Contemporary Art and Culture, curated by James Surls at Houston Center for Contemporary Craft, October 13, 2006–January 14, 2007.

Cover: Charmaine Locke, *Open Book*, AP, 2004–2005 (installation view, Carbondale, Colorado, see pp. 62–63)

Frontispiece: Brian Reid, *Hourglass*, 2005 (see pp. 68–69)

Distributed by
University of Texas Press
Orders and Customer Service
Box 7819
Austin, Texas 78713-7819
Phone orders in the U.S.: 1-800-252-3206
Fax orders in the U.S.: 1-800-687-6046
Fax orders outside the U.S.: 1-512-232-7178
www.utexaspress.com

Houston Center for Contemporary Craft
4848 Main Street
Houston, Texas 77002
713-529-4848
www.crafthouston.org

© 2006 Houston Center for Contemporary Craft
All rights reserved. No part of this publication may be reproduced in any form or by any electronic or mechanical means, including information storage and retrieval systems, without permission in writing from the publisher, except by a reviewer who may quote brief passages in a review.

All artworks © 2006 by the respective artists unless otherwise noted

M.C. Escher's *Bond of Union* © 2006 The M.C. Escher Company-Holland. All rights reserved.

Quotations from unpublished poetry by Robert Creeley © 2006 The Estate of Robert Creeley. Used by permission.

ISBN-10: 0-9787407-0-X
ISBN-13: 978-0-9787407-0-2

Library of Congress Control Number: 2006930849

Contents

Director's Foreword

There are so many reasons to feel proud of "Finding Balance." Its premise—
an artistic exploration of the forces that bifurcate our society along gender lines—
is at once personal and universal, timeless and timely. The works in the exhibition
are impressive in their diversity of scale, medium, and motivation. The intellectual capital
invested by James Surls, Charmaine Locke, and Leonard Shlain has produced a theoretical
stance that is remarkable and thoroughly captivating.

After a fruitful push to establish itself in its first five years, Houston Center for
Contemporary Craft might now be tempted, one supposes, to plant its flag and lay claim to its
hard-earned turf in the craft terrain. Instead, like any imaginative organization committed to
growth, the Craft Center is already examining itself . . . and challenging assumptions about
the field. With a realm as broad and multifaceted as craft, why choose a single path?

"Finding Balance" represents a confluence of perspectives, ideas, and talents that
could have only happened at this place and at this moment in time. Its quest for balance
—or, at minimum, an understanding of where imbalances exist in our culture—is amplified
by the ever-present tension and intersection between craft and art. Any perceived differences
between the two worlds become irrelevant in this context. It's what we learn from asking
the questions that matter. James Surls is a masterful provocateur. The intensity and
sincerity of his focus has been breathtaking.

The search for balance and understanding is not new to an organization that
celebrates the artists . . . the objects . . . the media . . . and the traditions of the handmade
that are germane to our culture and yet most often taken for granted. As its name suggests,
Houston Center for Contemporary Craft naturally embraces the contemporary expression
of creative energy, form, and ideas. "Finding Balance" gives us the opportunity to activate
that expression in ways that are bigger than any one of us. If people are drawn in to the
ensuing dialogue because we are identified as a home for craft, we'll be duly pleased; if
they are enticed regardless of the fact that we're a craft center, even better.

James Surls and all of the participating artists have given us a remarkable vehicle for
discussion and discovery that will continue well beyond this exhibition, and I thank them
for that. The Craft Center owes a tremendous debt of gratitude to Sara Morgan and
Beverly Berry for their tireless efforts to promote "Finding Balance." So many others have
contributed their creativity and hard work to this project. In particular, I want to acknowledge
staff members Jon Cook, Vicki Lovin, and Amanda Clifford, and former staff member
Amy Schilder, as well as Polly Koch, the editor of this catalogue, and Don Quaintance, the
catalogue's designer. To Ann Lancaster, my predecessor and the co-instigator (with Sara)
of this exhibition, I extend special thanks. On behalf of the curator, James Surls, I thank
Julie Tobolowsky for her participation. The network of support—traversing the country—
has been a source of inspiration and encouragement to us all.

—*Kristen B. Loden*
Executive Director, Houston Center for Contemporary Craft

Curator's Statement

When Sara Morgan, founding president of Houston Center for Contemporary Craft, came to my studio over two years ago and asked me to curate an exhibition for the Center, the first question that came to mind was not if I would do it, but rather what would be the core context of the exhibition. What would be the central theme that would hold the exhibition together? What would the exhibition be about? I turned inward to the heart and the soul of my personal world to give me guidance to answer these questions. My belief is that the mystery in art should give us a sense of meaning and purpose, so I looked to the most important things in my life and concluded that they were to find a personal balance both within myself and in my relationship with my life partner, and a concern for the well-being of my seven daughters and how they would be treated in their life's endeavors. I took the need in my own life of finding balance and projected it onto the world at large.

The need for finding balance in self and in union is as old as humanity and has never been easy, particularly when juxtaposed with the paradoxical need for personal power as well as group power as it relates to the male of our species. There is no question that history has been written and marked by males; I have to accept that as fact. The question then arises, where does that leave my daughters (who are but metaphors for every daughter)? The question of finding balance, already a monumental task on a personal level, becomes an even more overpowering one on a world level. How do we as a people find what we say we need?

My daughter Eva and I once sat in front of my computer and watched list after list of women's organizations scroll by. There are literally thousands of them in every state in the U.S. and around the world, and it seems as though ninety percent of them are there to help protect women from men. It is a staggering thought on any level you look at it. I am of the age to have been present during a time when major movements to bring equal rights to all were upon us, when women and other groups were struggling for basic freedoms. So many have been making the efforts for change for so long that maybe we have assumed their work was done, but clearly this is not the case.

I then looked around the so-called high art world today and wondered, is glamour and fashion, the hip and commercial, art that is slick and well-designed, new and smart, all there is? What do we as artists, as a people, stand for? What truth deserves our focused attention? This exhibition "Finding Balance" will create but a small ripple in the vast waters of the high art world simply because the art elite's history, from the "modern" era to now, has been to close ranks around its members. Read *The Last Folk Hero* by Andrew Dietz, then multiply its conclusions through the striations of the art world today, and you begin to get a picture of the uphill struggle that is before us. When I look for heroes in this endeavor, I see Joseph Chilton Pearce, whose book *The Crack in the Cosmic Egg* was at my bedside throughout the mid seventies; I read it so many times that the pages wore thin. I also picture Lucy Lippard, Susie Kalil, and Carolyn Merchant as buffers between me and an off-kilter world. I also look to artists like the eleven in this exhibition, selected

not because their work fits snugly within the concept, nor because I can make the belief fit their art, but because these two aspects meld each into the other to represent the ideals of this grand premise. The questions for all spectators to ask of these artworks are basic. What are you, and why are you here? What do you represent? What are you symbolic of? What are you telling me? It is my wish that this art speak to you, but you have to be willing to look and listen, to see and hear.

An equally important component of organizing this exhibition was to find a writer with knowledge of, and belief in, the subject at hand. I chose Leonard Shlain to write the central essay for the catalogue. His books *The Alphabet Versus the Goddess* and *Sex, Time and Power* are in-depth studies shedding light on this male/female imbalance. I believe no other writer of our time has devoted more to the understanding of why this lack of balance exists than has Shlain. I trust that his essay "Finding Balance: The Recalibration of Gender Relations" will make you think anew on this very old and haunting subject.

I also asked Charmaine Locke to write the introduction for this catalogue, giving her own response to the exhibition. She has been my sounding board on this subject for the last thirty years. It is her song I hear as I move through my days on this earth, and it is her questions I try to answer to make me a better man. Is God king, lord, ruler, and master, having dominion over heaven and earth? If the answer is yes, then God is male, and we can go back to sleep for another thousand years or until we are ready to reconsider the question of harmonic balance. Finding true balance in the personal sphere as well as in the world at large will require some major shifts in our thinking. I believe the fuel is ready for ignition, fired by creative people with the need to understand and the willingness to make such shifts.

Shifts in thinking are never easy, and starting points are sometimes unexpected and small. I think that mounting this exhibition in an art center devoted to crafts is significant on all fronts. It takes a shift in the thinking of all concerned for the boundaries of what is craft and what is art to melt away in face of the more important issue of the content of what you are being asked to consider. In this exhibition, I am crossing the line between what is craft and what is art and melding them into one.

In the end, the struggle to achieve a balance of the masculine and feminine may take hundreds or even thousands of years, and true balance in a harmonic sense may be unattainable, but it seems as though so many have made significant achievements in the last fifty years that the time is right for there to be more public conversation on the subject. I can take no credit or responsibility for anything other than my personal existence, but I also say that it is my hope that this exhibition will recharge the will of those who have been pulling the load for the last half-century and move this subject to the forefront of our minds.

—James Surls

ESSAYS

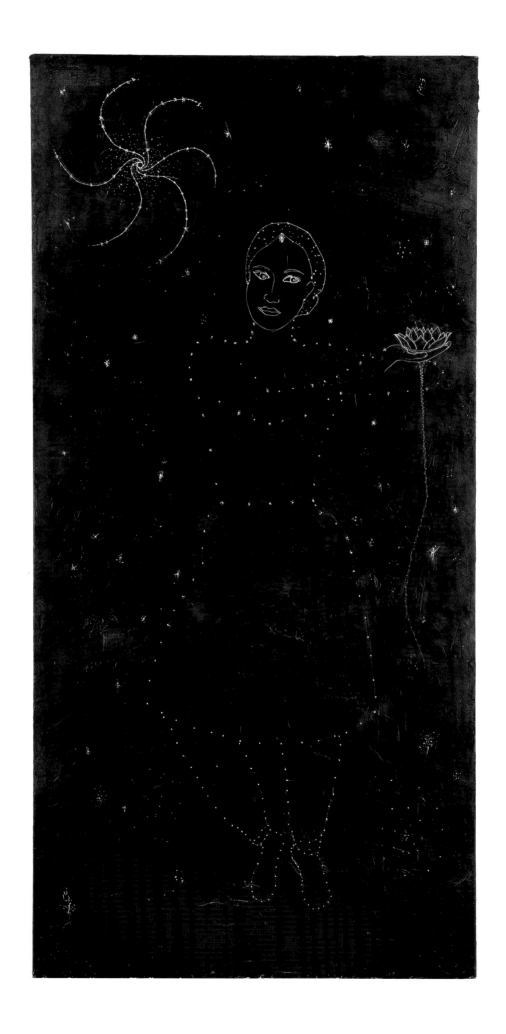

Introduction:
If in the Beginning There Was One

I f in the beginning there was One, there was harmony in the Oneness. But as variety and diversity expressed itself, chaos emerged as the ruling order, at least on the individual and microcosmic level. Somewhere on the larger scale, it could be said that an order prevails, but harmony and balance is an elusive and fleeting experience for the majority of the living components of the universe.

Most people accept this as the condition of life—the struggle against chaos and disorder. Some embrace the state of imbalance. They range from those who see any quiet routine as dull and void of "life" and so seek out stimulation, action, excitement, to those who diabolically set out to destroy life, who despise peace and live to encourage chaos in the universe, to set life on its ear. Others strive for serenity. There are individuals who radiate peace, who have desired harmony and found a way to calm the storms that rage around them. But most humans are content to treasure the rare, momentary glimpses of tranquility that they can carve out of the onslaught of existence.

In the 1950s in the United States and what we call the Western World, many experienced a fleeting sense of tranquility, a very brief period of relief from the chaos that had just engulfed much of the world. The destructive impulses that had gripped the jugular vein of civilized society, and spread ruin on such a massive scale it is virtually incomprehensible to a sane mind today, had retreated into a small cloud on the horizon once again.

In the century 1900–2000 AD, humans annihilated over 200 million of their own kind, the bulk of those deaths in the first fifty years. Cause: Unknown. How can any words, concepts, constructs, hypotheses, or analyses truly grasp such actions? It defies rationalization, justification, or explanation, these multiple machinations from hell. Yet we wanted to comprehend it, to work our way into the heart of the perpetrators. Why? In the hope that we could prevent such a thing in the future. Instead, the nuclear meltdown of Hiroshima that brought an end to battle congealed into a massive metallic pool. The U.S. moved into the Korean War, the Cold War, and Vietnam; other smaller aggressions

Fig. 1
CHARMAINE LOCKE
Night Wonder, 2005
Plaster and shoe polish
92 x 48 inches
Courtesy of the artist

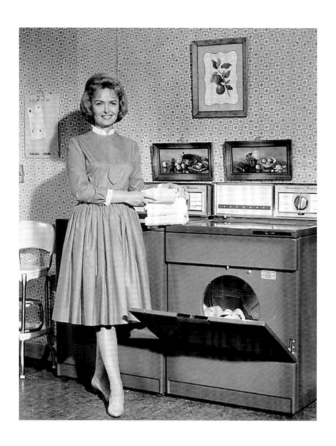

Fig. 2
Publicity still from "The Donna Reed Show,"
c. 1960

followed quickly on the heels of the cessation of the major conflicts. The pool started to heat up and liquify, boil and brew, finally erupting into the ethnic, tribal, and regional atrocities that characterize the conflicts of the latter days of the century and the start of the new millennium.

The brief interlude of stability in the 1950s, though some would argue that there was not one at all, expressed itself in the U.S. through a reaffirmation of "normalcy," a return to things as people remembered them to be before the disruption of the war, a reestablishment of traditional ways. An attempt was made to reassert the "right" way to live as opposed to the "wrong" that was so apparent and weighed so heavily on the collective psyche of the world. In the effort to purge and cleanse and create a "perfect," idealized version of life, errors were made on the flip side of the coin. As is so often the case when the pendulum swings the other way, some mistakes were avoided while others were made.

The problem was that the technological innovations of the modern age that had come about as a result of the technology of war had changed the world drastically. It was not possible to return to what had been. The TV images of the "perfect" father, mother, family, home, and community that were projected as plausible models of living failed to materialize, and instead the contemporary suburban community and the households of the disintegrating inner cities of the old urban centers became the predominant family configuration. The housewife of the 1950s, with the work-saving appliances that were to transform her life, instead saw it transformed into forms that had not been envisioned. Men also found new work environments and regimens that were frequently not all they had planned or imagined. But women experienced the greatest change.

Many women who had moved into the job sector outside the home during the war continued on in those positions. More doors were opened to women, and more women were welcomed into colleges and universities and subsequently moved into higher positions in the professional world. There were magazines conceived of by women, written and run by women, about women's issues. The magazines sought to cover the activism of the time and challenge the positions of those in power and those who tried to derail the progress being made. The people involved in the feminist movement and those working alongside in the ongoing civil rights movement were seeking to uncover the sources and root causes that had denied equality for women and minority groups throughout history and to uproot the status quo.

The illusory life model set up in the 1950s thus grated upon, and clashed with, the harsh realities of inequality, injustice, and governmental deceits. Another debilitating war led to increasing hostilities and conflicts as the leading edge of radical elements in the freedom movements demanded a reevaluation of where the country stood in relation to its founding principles. Growth and change did occur following the intense push of those movements. But the assassinations of leaders and groups splintering into factions, as well as the real advances and achievements gained, brought the "revolution," as such, to an end. Individuals found new ways to create change, going underground or melding back into the social fabric to do the work, and they are continuing the evolution.

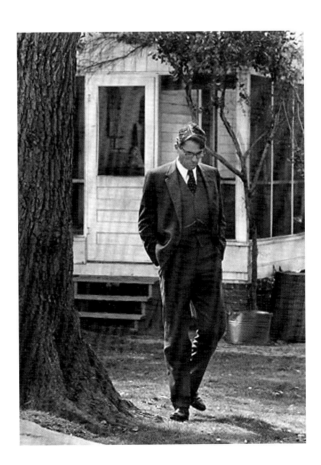

Fig. 3
Gregory Peck during filming of "To Kill a Mockingbird," 1962. Photograph © Leo Fuchs

The question is, how did the progress and advances accomplished as a result of this era of confrontation affect the lives of people today? Have the issues of imbalance been resolved or are we merely further down the road on a quest that has no end in sight?

In the 1960s and 1970s, many of the gender-related questions centered around the nature-nurture debate. How much of "maleness" or "femaleness" are we born with, genetically stamped into our personalities, and how much is instilled as we model ourselves after previous generations, cultural stereotypes, and advertising and media imagery? Many adamantly argue that all human behavior is embedded in our genes and we come into the world a fixed entity. Others defend just as strongly the belief that we are John Locke's *tabula rasa* or "blank slate," waiting for the imprinting process to form the personality. Certainly, there is a combination of the two at work in a process that lays down a formidable blueprint at birth that gives even newborns some of the recognizable elements of the individuals they are, but that very quickly begins to be molded and shaped by the environment and the people that surround them. The dynamic of the interaction of unique sets of genetic predispositions with the myriad elements they encounter throughout the formation of a life yields the endless diversity of humankind.

There are scientists who are investigating genomes and who claim that there have been significant changes within our genetic structure over the last fifty years, and they are linking these changes to alterations in specific human behaviors. Culture and society have adjusted in response to the changed perceptions of male/female roles and the rights of minorities, and the demands for inclusion and equal access. The two levels of change, at the genetic level and the societal level, have brought about a dramatic shift in Western culture.

The opening of traditional male territory to women has revealed the enormous capabilities of women beyond the scope of "feminine" roles formed over millennia. Men, too, have expanded their conceptual boundaries of what are appropriate roles for themselves and their partners and children. The limitations and possibilities for each gender have been altered and pushed beyond previous delineations.

Equilibrium: a state of balance due to the equal action of opposing forces

The premise set out by the curator of this exhibition is that this group of artists is reflective of a trend, within the broader community, to access new patterns that will encourage more balance both in relationships and in the inner worlds of individuals (and one could hope eventually in the larger world). Artists have traditionally been sensors and reflectors of their times and cultures; even if they do not engage in a conscious act and system of analysis, they still systemically absorb and translate our contemporary dilemmas.

Balance is synonymous with equilibrium, which infers the existence of two entities having the same value, having qualities that are appraised at the same worth on some scale of measurement. Certain works in the show impose a similar logic, a precision, on some facet of life. Through the technical processes used, they create an illusion of order or find a momentary stability and, by sealing it in the artwork, give it permanence in the world. Others dive into the cellular levels and freeze-frame the chaos and destructive

elements found there. Some combine the two to refer to the façade of normalcy while the frenetic dance carries on under the surface. Other works describe an evolutionary track from states of disunity and mayhem to a level of order and tranquility. But nowhere is there a sense of a world in balance or even that some major components are in balance. To the contrary, there is a consistent affirmation of imbalance.

> Balance: to arrange the elements [in an artistic composition] so as to express a sense of harmony

Seeking balance in one's psyche or in one's world is a rare endeavor. It is not the easy path and does not offer immediate or direct results, so it doesn't find a comfortable home in our culture. Therefore, it makes sense that those in our culture who have already chosen alternative paths, the artists, would be more likely to integrate this quest into their lives and their lifework.

Yet the work in this exhibition is more a description of the territory to be traversed, a reconnoitering of what lies ahead in preparation for the establishing of "a more perfect union." The artists here are looking at what causes the state of imbalance to learn better how to excise it and neutralize it, rather than suggesting what reality might be like. The insinuation is that the creators are somewhere along the trail: the quest has begun.

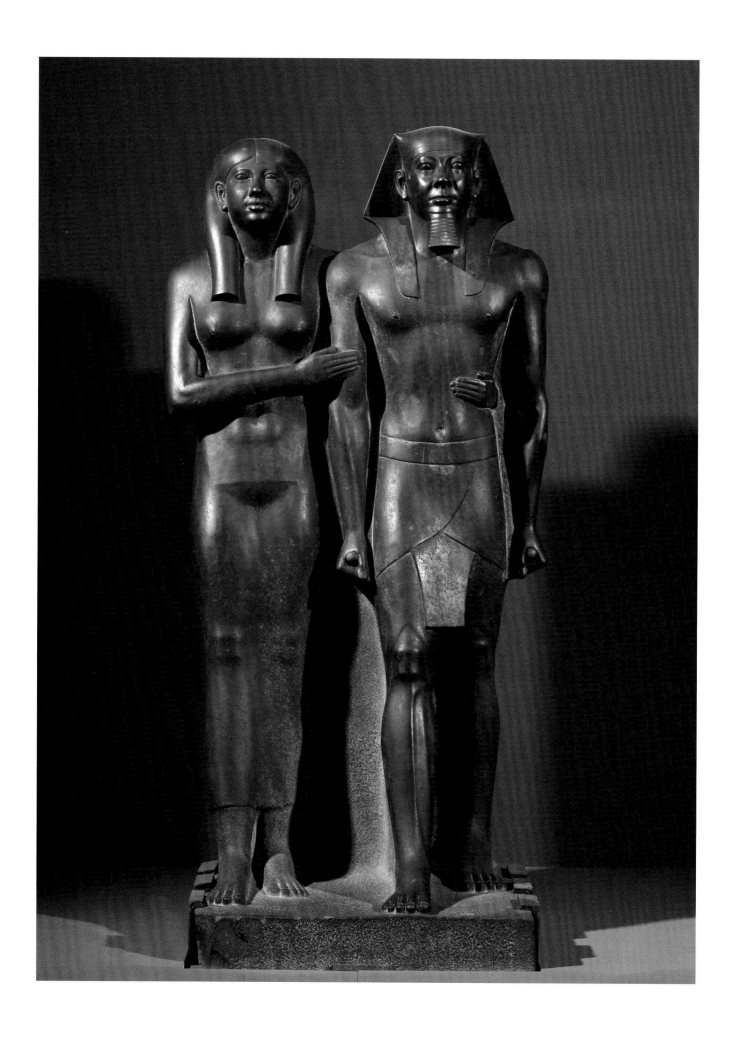

The Recalibration of Gender Relations

LEONARD SHLAIN

Visualize a stroke victim. Paralyzed on one entire side of his body, he awkwardly shuffles along, dragging his useless leg while keeping his oddly bent, unusable arm close to his side. One half of his face, previously the most emotionally expressive part of him, registers a waxy flatness indicating the atrophy of the once finely tuned delicate muscles that lie beneath. When he speaks, if he can, his words are slurred and sometimes incoherent. In conjuring this image, we witness a person who is half the human being he once was and who is operating at considerably less than half the potential he would certainly have if he were whole.

This image of a hemiplegic is an apt metaphor for the present state of gender relations in many parts of the world. Observing the daily news, evidence abounds that many societies repress women, thoroughly suffocating their creative potential. At its worst, institutionalized patriarchy marries off child brides to old men, sequesters mature women, promotes sexual slavery, endorses female genital mutilation, and imposes draconian dress codes that serve to make women all but invisible.

The happiest and most successful contemporary societies are those in which women have achieved near equal parity with men in terms of political, economic, and social power. The general quotient of productivity, abundance, democracy, and tolerance is the highest in those places where men and women behave with respect and compassion toward each other. However, the number of women in the world forced to adapt to deadening cultural mores designed to keep them "in their place" remains persistently high, and it is this perverse and counterproductive outlook that is preventing the human species from getting on with attaining its next level. Resembling a hemiplegic, we must rehabilitate our culture by reinvigorating its missing half; otherwise, we must surely suffer more decline. Yet, in the midst of this doleful story, numerous signs have surfaced that indicate that patriarchy is losing its grip.

So how did we arrive at this paradoxically dreadful, yet hopeful crossroads? Are patriarchal attitudes the result of cultural conditioning, or are they all precoded in our genes?

Fig. 4
King Menkaure (Mycerinus) and Queen
(possibly Khamerernebty II)
Egyptian, Old Kingdom, Fourth Dynasty,
reign of Menkaure, 2490–2472 B.C.
Graywacke with traces of paint
56 x 22 1/2 x 21 3/4 inches
Museum of Fine Arts, Boston

Was Freud right when he proclaimed, "Anatomy is destiny"? If not, then how must society change to effect change? Before attempting to answer these questions, let us first investigate how we arrived at this portentous but expectant juncture.

Anatomical and physiological developments that occurred in the prehistoric Pleistocene age profoundly shaped our gender relations. First, we are the only animal that walks heel to toe, and second, we have the largest brain-to-body ratio of any species. The hominid ancestor that made the fateful decision to stand up and begin walking on two feet instead of four paws could not have known that this act would set in motion events that would shape all future human sexual relations. Aligning the vertebral column perpendicular to the earth, instead of horizontally, positioned a mass of internal organs that towered over our bipedal hominid ancestor's pelvis. To prevent the unfortunate individual from being turned inside out when strolling after a particularly heavy lunch, the bony hole in the pelvis narrowed. Even as the pelvic inlet's circumference constricted, the brain of this two-legged creature underwent a remarkable hyperinflation, resulting in a one-third increase in volume, all in a very short period of planetary time.

This led to an evolutionary crisis with the advent of *Homo sapiens* approximately 150,000 years ago. The fetal brain had ballooned so that it could no longer easily negotiate the ever-constricting pelvic inlet. Females sought help to deliver their young, a remarkable biological event not present among the mothers of other creatures. And eventually, somewhere, sometime, a healthy young woman had growing within her a new life whose head was simply too large. During the delivery, her baby became wedged. After a prolonged labor, she died. Her baby died. Those in attendance could do nothing to help. The laws of physics superseded the strength of her uterine contractions. Unfortunately, she was the first of an avalanche of young mothers to die. For the first time in the history of any higher animal, extraordinarily high numbers of healthy females began to die in childbirth. The percentage of stillbirths grimly paralleled the rise. The significant number of mothers and their newborns lost trying to edge past this danger was a wasteful reproductive strategy that could have been expected to toll the death knell of the line. Yet it created precisely the kind of crucible in which a species must adapt—or go the way of the dinosaurs.

The big-head/narrow-pelvis conundrum forced a momentous epiphany to erupt in the emerging consciousness of the ancestral human female. An extreme environmental stress originating from within a woman's body that did not similarly affect a man was a highly unusual twist of natural selection. She had to evolve cognitively faster than the male in the area of sexual relations. To survive, she had to grasp the connection between sex and pregnancy. This crucial insight demarcated a sharp line between all the organisms that had evolved before this event and the solitary one that evolved after it. The new *Homo sapiens* female acquired the ability to arch over the present in order to connect the past with the future. This skill does not exist to this extraordinary degree in the mind of any other animal. Wide-awake to the dangers of sex, the human female, haltingly at first but with increasing assertiveness, began to resist the hard-wired commandments demanding that she mate whenever she ovulated.

To achieve, first, the extraordinary insight concerning sex/pregnancy and, second, an extraordinary power to refuse to engage in sex, she had to develop an ego-consciousness

capable of disengaging from the *Be-Here-Now* mentality used by all other animals. There came into existence within her brain "a room of her own" high above the hurly-burly of her insistent instincts and hormones. The story of her release from the slavery of brute instinct is the preface to the tale of how modern humans, both men and women, came to be the way we are. *Homo sapiens* means "wise man." So great were the changes in the female of the new species compared to those of the male that it would have been more accurate for scientists to have named our genus and species *Gyna*[1] *sapiens* rather than *Homo sapiens*. I shall acknowledge what I believe to be the female's role in advancing our species by using *Gyna sapiens* when referring to the ancestral females of the species *Homo sapiens*.

The female—not the male—underwent a major transformation because it was the female—not the male—who was dying in childbirth. The dictates of natural selection would predict that she, rather than he, would evolve novel adaptations to the challenge. By wresting control away from her sexual urges, *Gyna sapiens* and her daughters exerted discipline over the process of conception. It was small compensation for the increased risks she exposed herself to whenever she became pregnant. If she was going to be the one who died in childbirth, then it was she who had best be able to choose when, where, how, and with whom she would become intimate. Other females of some species may be able to choose upon which male among multiple suitors they wish to confer their favors. An occasional female of any species may decide not to mate with anyone or at any time. But the human species was the first in which *all* the females evolved the capacity to consciously decide to refuse to mate during any one ovulation or all the time.

This one breakaway female primate not only underwent a major overhaul in the design of her brain (as did the male), but in addition she experienced a gear-grinding resetting of the major timers within her reproductive system. For a woman to make the connection between sex and the first signs of pregnancy, she would have had first to recognize a time period longer than a month. To accomplish this, natural selection traded a bumptious periodic estrus for a vexing periodic menses that was associated with physical, physiological, and psychological changes she could not ignore. Further, this monthly visitation was punctuated with the most dramatic sign there is in animaldom—external bleeding. No animal can afford to ignore external bleeding. Among the 4,000 species of mammals, of which humans are one, there is no other female that experiences as much menstrual blood loss as a human. Perhaps these dramatic changes that occurred to the human female's reproductive life cycle served primarily to teach our species the invaluable secret of how to maneuver within the dimension of time. This insight allowed humans to escape from the thin slice of the ever-present *Now* occupied by other creatures and roam the canyons of the past as well as explore the misty plains of the future.

The rapid changes in *Gyna sapiens'* sexuality confounded the male. A perplexed *Homo sapiens* discovered to his dismay that he had to respond to the challenge she posed to him or lose the opportunity to pass on his genes. Changes simultaneously occurring in his genome compounded his problem, particularly his increased eagerness to have sex with a woman, any woman. Other males of other species express interest in females only when the females enter their period of heightened sexual receptivity called variously "rut," "heat," or "estrus." The human male became the first male of the multitude that

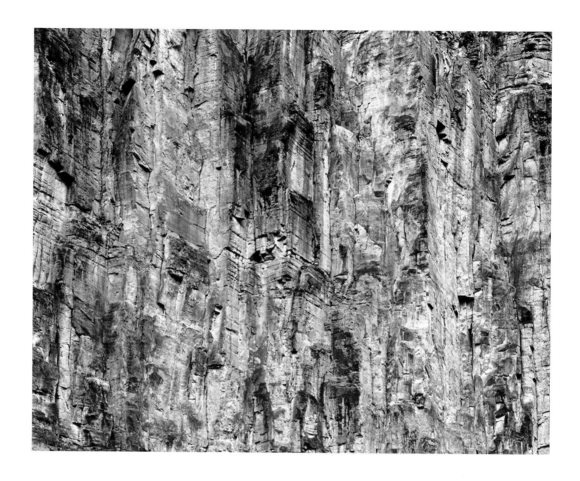

Fig. 5
JIM BAKER
Parashant Canyon, Arizona, c. 1990
Photographic print
20 x 25 inches
Courtesy of the artist

desired sex—with any female—*all* the time. The psychosexual emergency precipitated by this dissonance of desire between the sexes set the stage for a battle, the tocsin sounds of which have reverberated down through all the generations ever since.

The human species has a further peculiar physiological feature: females—but not males—have fewer circulating red cells. The magic behind a red cell's seamless performance is the protein called *hemoglobin*. And like a set of nested Russian *babushka* dolls, at the core of hemoglobin lies the element iron. Iron and oxygen, due to the salutary arrangement of their outer electron shells, eagerly seek out each other's embrace. Once merged, the two form a molecule called iron oxide. Hemoglobin transforms iron's strong affinity for oxygen into a delicate "grasp and release" maneuver, allowing oxygen to be easily acquired in the lungs and readily relinquished further down the line to the cells. Iron is a critical component of human vigor, intelligence, and health.

Considering how important adequate circulating levels of iron are to the human venture, a strange thing began to occur to the human female. Obscured by her flamboyant reproductive changes, *Gyna sapiens'* internal milieu began to exhibit a perplexing inability to retain iron atoms. The loss of iron atoms from multiple avenues throughout her fertile life imperiled her health and destiny. The homeostatic warning light on the gauge tracking her serum hemoglobin levels blinked ominously during the time she was gestating, birthing, or breastfeeding her baby. Some other species also manifest a male/female hemo-

globin disparity, but they do not have to answer to a greedy, demanding brain that can appropriate over one-fourth of all the hemoglobin's precious oxygen cargo. Another factor added to her potential peril: the breastfed infants of other mammals do not have iron-hungry brains that more than double in size during the first year of life.

While there are adequate quantities of iron in most vegetables, the food highest in easily absorbable iron is meat. When humans trekked north out of Africa 70,000 years ago, they inadvertently walked into the teeth of one of the worst Ice Ages the planet had experienced. There were not sufficient quantities of iron-rich vegetables available for foraging in the prolonged winters of the northern climes that humans chose to inhabit. Meat, containing its precious iron atoms, became an indispensable part of the human diet.

This then was the dilemma. By exercising her power to postpone sex, women gained a significant advantage over men; men, however, without the burden of childrearing, could more easily obtain the essential item, iron, that women and their babies needed. As a consequence, men enthusiastically increased their interest in the hunting life to acquire the nuptial gift most desired by ancestral women—meat. For the first time among the animals, Mother Nature required that the members of the opposite sexes enter into complex negotiations in order to mutually agree on the terms and conditions under which they would engage in consensual sex.

Another major insight occurring to *Gyna* and *Homo sapiens* as a result of breaking through to the future was the realization that among the many diseases that harried them, the only one that carried a one hundred percent mortality rate was life. Everyone, no matter how young, strong, or ebullient, was doomed to die. This epiphany spooked men more than it did women, and knowledge of death initiated a sea change in consciousness second only to the connection a woman had previously made between sex and pregnancy.

I base this conclusion on my personal observations. As a surgeon for thirty-five years, I have had to inform many patients after an operation that they had a terminal illness. On average, men in all age groups take this news much harder than women do. They more often insist on heroic and drastic measures to stave off the inevitable. Men fear death more, though of course there are many exceptions to this generalization. I have witnessed many women fight tenaciously to forestall death, and I have attended many men during their gracious and courageous last days. Nevertheless, art, custom, culture, religion, mythology, and literature provide ample supporting evidence of this gender difference in attitudes toward death.

Asked to create a metaphor for time, a woman will usually draw a circle. Ask a man the same question, and he will, as often as not, draw an arrow. Perhaps women, being closer to the cycles of life, view death as an ineluctable phase in the turning wheel of fate. Men, on the other hand, tend to conceptualize life as moving along on a linear trajectory with a beginning and an end. Women face death on a more intimate basis than men. Every woman is aware of the danger of childbearing, a truth more trenchant in ancestral times than the present. Each menses to a woman trying to conceive represents a *petit mort*. She knows the pain of the death of her children, both before and after birth. She lives with the knowledge of death from the moment she knows she can give new life. Men must actively seek out death experiences, as they do not confront them on a routine basis.

The awareness of a *future death* changed the outlook, demeanor, and aspirations of the human species, separating them further from both their close and distant relatives on life's extensively branching tree. Increasingly complex rituals, beliefs, and customs emerged that were attempts to soften the blow.

Soon after these discoveries, the facility to think ahead led to the third transformative insight. A man finally discovered his role in the sex/birth process and realized he fathered specific children. This knowledge alleviated some, but not all, of his limited-life anxiety. Awareness of paternity spawned in him an intense interest concerning the fate of his offspring never witnessed before in the males of any other species. For the first time, a male wanted to keep track of the exact whereabouts and fortunes of his genetic legacy. He hoped to live on through the memory of his children and he committed himself to being involved in their upbringing. A powerful emotion, hitherto never experienced to the same degree by the male of any other species, began to move him. Sustainable over an extended period of time, love greatly aided his comity with both his offspring and the mother who bore them. His burning desire to know his children required establishing an entirely novel relationship with their mother. The new neuronal and hormonal systems sustaining a sense of love, however, had to incongruously coexist alongside others that sounded the clarion call to arms or the frenetic cries of the hunt. Men had to be killers and lovers simultaneously, a merging of opposites that has never completely succeeded.

These three insights concerning birth, death, and paternity, all of which are intimately bound to sex and indirectly connected to iron metabolism, molded every culture in the world into their present shapes. Men eventually realized that the only way they could be confident that a man's "begats" were his and his alone was to plot together to restructure society's sexual relationships. To accomplish their long-term goals, men set out to achieve the seemingly impossible—control of both women's sexuality and their reproductive abilities. Women were at a significant disadvantage if they tried to resist these male impositions because they were weaker physically and their babies' enormous needs required that they constantly seek male support. Despite these evident drawbacks, women were not entirely without resources. Many were able to influence men by subtler means. Still the evidence remains undeniable: men have craftily sought ways to blunt the power of women's choice in sex.

Our species is 150,000 years old. In the last 10,000 years, we have experienced a series of technological revolutions that have markedly affected the relationship between men and women. The substantial creation of wealth and the social upheaval attendant upon the rise of first agriculture, then industrialization, and most recently technology tend to obscure the important fact that all of us are still walking around with a nervous system designed to work optimally within a small band of hunter-and-gatherers. The most critical legacy of those bygone times was a sharp division of labor between men and women, a necessary condition for the survival of the individual and the progression of the generations. The key three insights into birth, death, and paternity triggered a massive reconfiguration of that society. Many of the sexist biases and social institutions that persist in the world came into being as a result. The two most pervasive that affect relations between men and women are misogyny and patriarchy.

Misogyny is a disdain for women and denigration of the values commonly associated with the feminine. Patriarchy is a set of institutionalized social rules put in place by men to control the sexual and reproductive rights of women.

When asked, many men will gallantly express their admiration for women in general and profess a profuse love for their mate in particular. Despite these touching personal testimonials, global society is rife with misogyny and patriarchy. The historical record presents an even bleaker picture. The Western canon consists of many brilliant tomes written by esteemed white males, the overwhelming majority of whom were unapologetic misogynists. Isaiah, Jeremiah, Plato, Aristotle, Paul, Pliny, Jerome, Augustine, Aquinas, Bacon, Luther, Calvin, Nietzsche, Schopenhauer, Marx, Hegel, and Freud ranged from outright woman haters to those who weren't quite as blatant but nevertheless strongly promoted the patriarchal agenda.

Even during the majestic periods in which human dignity flourished—Classical Greece, Renaissance Europe, Parliamentary England, Revolutionary America, and Enlightenment France—such champions of human rights as Socrates, Pico della Mirandola, Erasmus, Locke, Jefferson, and Voltaire did not consider the need to elevate women from their second-class status as an item high on their political agendas. Western culture had to wait until the nineteenth century before a prominent male philosopher, John Stuart Mill, was willing to stand up and speak out for women's equality.

The record in non-Western cultures is also dismal. Both Confucius and Buddha were misogynistic. Of the few leaders who seemed friendly to women, Jesus, Mohammed, and Lao Tzu stand out, but what they really had to say has been so filtered by subsequent patriarchal commentators that it is difficult *now* to know exactly what their true attitudes toward women were during their lives *then*. The history of Christianity, Islam, and Taoism darkly demonstrates that the religions that flowed from the teachings of these three influential leaders have been most unkind to women. In every case, after the death of the founder, men with harsh patriarchal leanings seized the power of the inkpot and revised in writing whatever gentle counsel the originators of these traditions may have had said to their disciples with respect to their original teaching concerning women.

Psychoanalysts, anthropologists, sociologists, physiologists, and feminist theorists have different answers to the question of why patriarchy has so dominated human cultures. Space constraints do not permit me to lay out the arguments all of the above have made to explain society's baleful patriarchy that has led to what Frederick Engels called, "the world historic defeat of the feminine." I can trace but one path that begins in adolescence.

Misogyny takes root and grows immediately after puberty when sex becomes the central issue in every boy's and girl's life. During the halcyon days of childhood, boys' attitude toward girls resembles the apathy that male mammals express toward females that are not in heat. Girls ignore boys nearly as much. And then the rolling wall of puberty, like a giant tsunami wave, slams into young bodies. This is the moment when the political agendas of the sexes sharply diverge. This is the moment when economic negotiations over sex become paramount. This is the moment when men confront the "world historic defeat of the masculine'" at the hands of mere girls.

Prior to the onset of puberty, a boy's testosterone levels are nearly undetectable.

Then the juice of Eros jolts his nervous system with a twenty- to fortyfold increase. Testosterone floods the young male's incompletely finished brain, creating a dangerous and unstable situation. Among its protean manifestations, the androgenic hormone boosts the level of the male's sexual tension to unbearable levels. While frequent masturbation offers him a partial solution, a teenager realizes for the first time in his life that he requires the intimate cooperation of a willing female. Therein lays the problem.

Boys enjoy playing games, and seek out other boys for group games. Put several of them together and within a few moments they will be engrossed in a cooperative form of play distinguished by clear winners and losers, and requiring minimal negotiation at the outset. (The arguments start shortly thereafter.) Rarely will a boy refuse an invitation from another boy to join a game. Imagine, then, a post-pubertal boy's surprise and consternation when he first invites a girl to play with him the game that has become the most fascinating and intriguing sport of his young life—the one in which the closer he gets to her bare skin and external openings, the more points he scores. The other player is, from all outward appearances, a member of the same team, but the boy soon perceives that he is dealing with an alien. She seems to speak a different language from the one with which he is familiar. Worse, he must play by her rules, and much to his surprise, despite her smaller stature, she is extremely effective at tenaciously guarding her goal. Initially, he may be convinced that it is he who is in control of the situation; after all, he is the one who initiated the game in the first place. Over time, however, he dimly perceives that she is setting the pace and conditions, and more often than not, he accedes to her requests in order to please her.

In those contemporary cultures in which harsh patriarchy has not yet destroyed a young woman's exercise of sexual choice, a young man's initial foray into this unfamiliar arena most likely occurs at a middle school dance. (There is no reason to doubt that some variant of this ritual also occurred in the Pleistocene.) Perhaps the first girl he asks refuses his offer to dance, confounding him by her inexplicable rejection. Rarely in his life has a potential playmate refused to engage in a game. If a conspiratorial peal of giggles among her close group of friends follows her refusal, then in addition to his feelings of perplexity, his nascent masculinity suffers a crushing blow. Our young explorer soon comes to the realization that his quest is going to be far more difficult than he had initially anticipated. Perhaps he is fortunate enough to be rich, suave, handsome, strong, athletic, and never at a loss for words. Even if he has all those qualities, convincing a girl to join him in the play called sex will remain a pointed-elbows contest of wills at this stage in their lives.

Throughout the animal world, males compete among themselves for the right to impregnate females, whether in schools of sperm racing toward a prize only one of them can win, or the very visible and resounding clash of locked horns on the elk's field of battle. Once a male has won the contest among other males for mating rights, he meets virtually no resistance from a female in heat. She desires sexual union as eagerly as he does because her hormones are firmly in control of her brain's behavior. Through impeccable timing, the height of her lustful frenzy coincides with the departure of her eggs from her ovaries. The irresistible siren song of her sexual instinct compels a female's willingness. In contrast, the human female is the only mammalian species that we know for sure has lost estrus

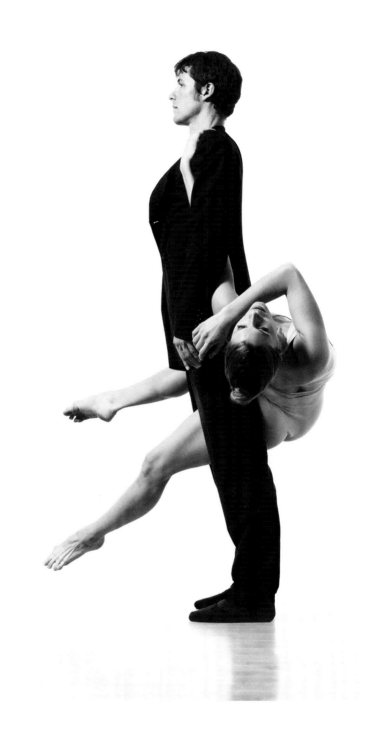

Fig. 6
Katie Dehler and Sam Chittenden,
Aspen Santa Fe Ballet, 2005
Photograph © 2005 Lois Greenfield

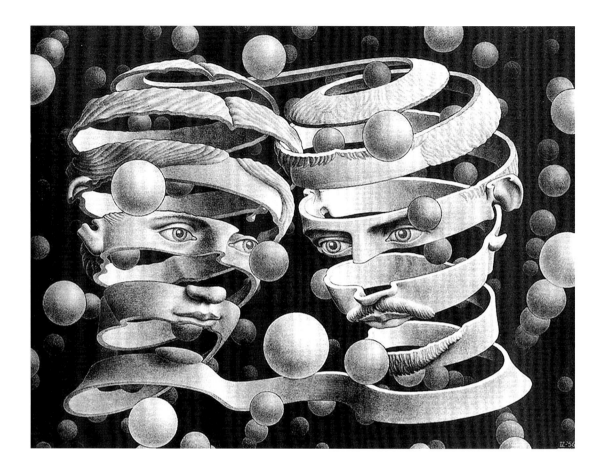

Fig. 7
M.C. ESCHER
Bond of Union, 1956
Lithograph
10 x 13 inches
© 2006 The M.C. Escher Company-Holland

(or its equivalent.) However, what she has lost, the male seems to have gained; a young male of the human species exhibits ample behavioral indicators signifying that he is in a state of full blown "estrus" *all the time*.

Behind every expectation is a frustration waiting to happen. Sadly, a young man learns to his eternal disappointment that the person of the opposite sex upon whom he has just recently fixated his attention is balky, recalcitrant, and uncooperative. It is his incredible frustration with his sexual counterpart's unwillingness to comply with even his simplest sexual advances that causes misogyny to rear its ugly head. Cultural convention and media may reinforce his feelings later, but this is the fount from which it springs. This is exceedingly unfortunate because his testosterone fog prevents him from seeing the major difference between his agenda and hers. At his young age, he is blithely unaware of the stakes involved—while he indulges himself thinking he is just playing a game, she is playing for keeps. For her, this is not a game, but the opening skirmish in a campaign she cannot afford to lose.

Elder women train girls very early for the mission they must accomplish post-menarche (first period). During her initial contacts with the opposite sex, a young woman must learn to recognize the key landmarks of the male mind's strange terrain and to quickly assess the outlines of his character. She must often make snap judgments so as not to

waste valuable time that could be better used birthing babies with Mr. Right. The considerable advantages afforded her by her youth and beauty during this early period of her life serves her well. Her ultimate goal is to negotiate his willing surrender—preferably "unconditional." She wants him to declare publicly that he will no longer seek the attention of any other woman and will devote his time, resources, love, and help in raising any children that may result from their passionate embraces. She knows that she cannot claim victory until she hears it in his voice, sees it in his eyes, reads it in his gestures, and feels it in her marrow.

From a young woman's perspective, this contest is a matter of life and death. At some tellurian level, she understands that she will soon be called upon to put her life on the line. If she survives the dangerous delivery of her offspring, she requires the impregnating male to make a very long and very intense commitment in order to maintain her health and ensure her ability to continue to birth intelligent babies. Parents, older women, and her culture's conventions constantly remind her that if she fails to secure a future reliable source of resources, the result will be catastrophic. And it doesn't matter how badly she herself wants to have sex. She *must* exercise restraint over her hormonal urges. She knows that her ability to withhold that which a man so hungers for is her most potent bargaining chip. Her agenda differs so markedly from his at this stage of life that his extraordinary frustration is unavoidable. *Her veto over sex is the primary source of her power and becomes the root of his anger.*

Many men resist the pull of misogyny and remain favorably disposed to gender equality. To a large extent, their mother's love undergirds their equipoise. Reciprocating that love allows them to translate the deep feelings they have for their mothers into loving relationships with their lovers, wives, sisters, and daughters. Maternal adoration is the balm that can offset the bane a man experiences when confronted by a woman's repeated failure to cooperate with his sexual agenda. Unfortunately, war, loss, illness, and catastrophe may prevent a boy from properly bonding with a loving mother. Surrogate mothers, sisters, aunts, grandmothers, teachers, and even fathers and grandfathers can often substitute for this crucial missing ingredient of a man's character, but a subset of emotionally damaged men exists for whom the art of loving women is a difficult and daunting challenge. Moreover, not all mothers love their sons equally and some even irreparably wound them.

In general, without the unguent of a mother's love to salve the erupting adolescent antagonism toward women, men may evolve a suspicious and angry attitude toward women, making it nearly impossible for them to love any particular woman. Many a woman married to a man lugging this lumber around in his unconscious storehouse has discovered that despite her love for him, the structural damage stemming from his childhood remains too extensive to repair. The most critical choice of her life often turns into a disaster as her mate behaves maladaptively toward her and disappoints as a father to their children. Of course, many exceptions to these observations abound.

Through persistence, a woman gradually convinces a man to compromise his primary reproductive goal of unfettered access to a variety of women, a dream he relinquishes reluctantly and a restriction for which he never really forgives her. In the springtime of his life when his hormones are in full flood, he is inclined to bargain away the right to be sexually free in exchange for exclusive sexual access. In the intense negotiation that occurs

between the sexes, she wants him to make this key promise to her. The likelihood that he is in love vastly increases his willingness to please her by agreeing. Male leaders of religion, government, and culture further women's agenda because they know that restraining the male's sexual urges reduces conflict, aids babies, and provides all fathers with an increased confidence concerning their genetic heritage. So the immense social pressure of culture is brought to bear on him. The weight of tradition, ritual, and taboo must be marshaled against his towering natural impulse to pursue *all women, all the time.*

Initially, his concession does not seem very important to him. His volatile mixture of love and lust persuades him that he is obtaining his heart's desire. And then passing time erodes the fortitude underpinning his promise. Familiarity gradually dims the intensity of his ardor. His hormones begin to back up and press against the thin barrier that culture constructed to hem them in. Testosterone urges him to follow the evolutionary imperative adhered to by 99.9 percent of male creatures—to spread his seed far, wide, and often.

A moment arrives in every husband's life when he begins to question the fairness of his decision to pledge himself to one mate forever. (The same doubt also occurs to his wife, but she is less likely to act on it because, once she has children, deciding to leave her mate is a more hazardous and difficult course of action for her than it is for him.) Many men experience a sense of guilt for their sexual fantasies and/or transgressions. A part of him resents women for preventing him from having what he wants. On the other side of this divide, a husband's failure to adhere to his "I do" oath in particular, and the male gender's failure to live up to women's expectations in general, induces women to harbor a deep resentment toward the male sex. This mutual rancor abets the war between the sexes and renews itself in every generation.

Further exacerbating a man's sense of pusillanimity when dealing with women is his realization that fatherhood is the least taxing route open to him to satisfy his longing to find a way to soften the terror of death. Children mean he can deposit a part of himself— especially his name—in the next generation. Although he also has the alternative option of performing a memorable heroic deed, the more reliable method open to the average man is to father children who adore and respect him. And so, a young man learns that not only can a young woman control his access to pleasure, but further diminishing his negotiating stance, she is also the guarantor of his lineage.

Men experience irritation with the hoops that they must jump through to convince a woman to say *Yes!* Chafing under their load of "shoulds" and "oughts," men crave to establish a social structure that will allow them to have their cake and eat it too. A man wants one woman to be exclusively his and at the same time he wants to philander. He demands that all the children "his" woman bears are exclusively his, yet he resists any restrictions on his sexual escapades, even if they result in his illicit partner's pregnancy. Men see no paradox in the contradictory goals of the double standard that has grown directly from the three grand transformative insights earlier mentioned: sex causes babies, everyone's gonna die, and his begets ensure immortality. This resentment has led men to resort to the powerful weapon they have at their disposal to wield against women—their ability to make public symbols. *The institution of patriarchy came into existence because men needed, first, to control women's sexuality and, second, to control women's reproductive*

rights. The first ensured he could relieve his intolerable itch on terms favorable to his sex; the second assured him his place in posterity.

The masculine half of the body politic also resists acknowledging the obvious: disdaining, ignoring, and dismissing its distaff half is extremely counterproductive. Until individuals, couples, and cultures can facilitate and appreciate the contributions of both halves of the human psyche, the human species will continue to be hobbled by this serious handicap.

What can we do to redirect culture's gender relationships and set them in a more congenial direction? The many framers of this question most often posit their solutions in the context of education. If only we somehow could change the content and context of what we teach children, then we could begin to eradicate this poison that prevents harmony between the sexes. Certainly education has a role to play, but in this essay I have tried to move the conversation away from an emphasis on culture and more towards the realm of genetics and evolution. Some might protest, claiming that this approach is but a warmed-over version of Freud's "anatomy is destiny" determinist argument that men have used to legitimize their dominance over women throughout the ages. That is not my intention. I do not seek to *justify* why things are the way they are, but rather to *understand* why they are the way they are. This must be the first step in the process to initiate meaningful change in our cultural institutions. Chiseled into the lintel above the entrance to the Oracle of Delphi in ancient Greece was Apollo's first commandment to all mortals, *Gnosti Seautum*—Know Thyself. This ancient Socratic imperative remains very relevant today.

Grasping the evolutionary reasons behind the many quirks in the human mating system will lead, I believe, to an improvement in the relations between men and women. This overriding of the "anatomy is destiny" conundrum is possible because we have arrived at a critical juncture in the life of our species. *Homo sapiens sapiens*, the doubly wise human as we used to be called, is presently undergoing a metamorphosis. We humans are in the process of changing into something else. A new species is being born right before our eyes, but because we are so close to the cataclysmic event, we cannot appreciate its full import.

In Buddhist parables, an ordinary man may behave in a selfish and self-serving manner until he becomes "awakened." To achieve this state, a man must withdraw temporarily from the world and turn inward. The transformation that is occurring within his soul is not visible to anyone observing him from the outside. Upon achieving enlightenment, the person is utterly changed and is said to have attained the state of *satori*. One so enlightened is freed from the obligation to return reincarnated to the world on another turn of the karmic wheel of fate. The Buddhists frequently use the metaphor of the metamorphosis of a caterpillar into a butterfly to poetically describe this transformation of the individual. Could it be that the entire human species began its existence as a collective caterpillar? As we enter our most environmentally rapacious stage, are we on the verge of transforming into the metaphorical equivalent of a butterfly?

Two and a half million years ago, the evolving hominid line differentiated away from its apelike predecessor by fashioning the first stone tool. Imagine the moment. A slow-witted, little more than pint-brained *Homo habilis* held a cobble in his hand and through

a concerted effort of sustained mental concentration conceived a tool residing inside the rock. The imprisoned tool could not be released from the stone unless the first *Handy man* (or *woman*) sat still and laboriously chipped away at one side of the rock. Employing patience and persistence, the first toolmaker was rewarded at last with a working stone tool that sported a crude cutting edge. *Homo habilis* continued to make this identical simple tool with very few modifications for almost the next one million years!

Then the next hominid version, bigger brained *Homo erectus*, figured out that a stone's cutting edge could be sharpened considerably if he or she simply turned the rock over and began alternating knapping each side. The bifacial hand ax fashioned in this manner sliced through hides and cut bone from joint much cleaner than those previously fashioned by *Homo habilis.* And again, while Acheulian bifacial hand axes, the signature tool of *Homo erectus,* have been discovered nearly everywhere our predecessor settled in Africa, Europe, and Asia, these artifacts remained mysteriously unchanged for the next 800,000 years. Anthropologist Glynn Isaac remarked disappointedly on this "shuffling of the same essential ingredients" for an extraordinarily lengthy period of time "in a minor directionless change."[2]

Then, 150,000 years ago, along came *Homo sapiens.* At the start of their adventure, some novel tool-making techniques appear in the archeological record. But the pace of innovation advanced with the speed of spreading molasses until rather suddenly *sapients* crossed some sort of an invisible barrier 40,000 years ago. Inexplicably, humans began to create representational art and elaborate grave goods, to consistently bury their dead, and to engage in ritual. Around 30,000 years ago we invented sewing needles and fishhooks; 15,000 years ago the first bow and arrow appeared. The pace of novelty accelerated with the agricultural revolution 10,000 years ago and went into hyperdrive in the last century. The amazing increase in the celerity with which humans embraced innovation has necessitated converting the 2,500,000-million-year curve from a geometric representation to a logarithmic scale for the last 1.5 percent of its length. In an hourlong film chronicling the hominid tool-making epoch, the industrial age of the machine would flash by in the last few seconds.

Whenever a measurement curve switches from a slowly rising horizontal one to a steeply ascending vertical one, conditions are favorable for a major transformation. Typically, this is the moment when the object being measured or observed changes from one state into another. This alteration in states occurs in a relative instant without any transitional gradations. In physics this process is called a phase change; in biology, metamorphosis; and in evolution, punctuated change.

Technological innovation has advanced so rapidly in our lifetime that it has become the primary environmental stimulus responsible for refashioning the animal that began life as *Homo* and *Gyna sapiens.* Linguist Derek Bickerton observed, "The two most shocking facts of human evolution: that our ancestors stagnated so long despite their ever-growing brains and that human culture grew exponentially only after the brain had ceased to grow."[3] Utilizing newly discovered technology, humans have brought about intended and unintended changes in both their external surroundings and each individual's internal milieu. Warnings about the impact of the negative consequences have been widely

Fig. 8
JAMES SURLS
Well Water (detail), 1990
Linocut
39 x 53½ inches
Courtesy of the artist

disseminated and have induced appropriate levels of anxiety in thoughtful people; the positive consequences, however, possess the power to transform us as a species.

At the outset of the human species, the limit of human intelligence was set by the diameter of the female's pelvis. Evolution could simply not push a bigger brained baby through that narrow opening. Primatologists examining the gestational periods of our closest primate relatives have concluded that the human female should be pregnant for eighteen months. But she must deliver her unfinished baby at the end of only nine months. Any delay beyond that time frame threatens both her life and the life of her baby. Natural selection's solution was to bring a human into the world premature and totally helpless. However, waiting for the baby on the other side of the mother's pelvic ring of bone were the missing developmental pieces. They are called culture and they were ladled back into the baby's brain through the agency of a remarkable new adaptation called language. Language and the cultural knowledge it contained can be thought of in modern computer terminology. Language resembles the addition of a peripheral device that stores information outside of the main computer.

Since the innovation of language, we clever humans have invented writing, and then libraries, and finally the telegraph, telephones, film, cell phones, telescopes, radios,

computers, and the Internet. These innovative additions to our innate brain power, more than anything else, are changing us as a species. And there is no evidence that the explosive technological progress we have been experiencing is slowing. Quite the contrary, we are entering a critical phase when our species will either drastically decline as a result of our rapid degradation of the earth's resources or, more likely, transform into a new species that we, who are in the midst of the transformation, cannot discern.

If long-lived intergalactic alien anthropologists were present at the birth of our species, they would express wonderment at the changes they observed happening right before their eyes. Witnessing the first *Gyna sapiens* die in childbirth 150,000 years earlier, they would recall the many dire prognostications for future prospects of the hominid line. And there would be similar bouts of hand-wringing as they watch African Eve's descendants now mucking up the planet they inherited. The more perceptive aliens, however, would discern the outlines of an emergent brave new species undergoing an unheralded form of metamorphosis. They would excitedly notify the mother ship that they were witnessing the birth throes of something that none of them could have anticipated. The old reliable parameters of physical attributes, such as brain size or bone length, cannot distinguish this new species from the old, but the dramatic changes in the way some men and women have begun to relate to each other can. *Sapients* are experiencing a period of punctuated change.

Humbled, perhaps, by the knowledge of how wrong they were when predicting African Eve's survival chances 150,000 years earlier, the aliens would most likely add the qualifier that their report on the mating patterns of this new species is a work-in-progress. They hedge their bets because the transformation they are observing is entirely without precedent when compared to anything that has occurred in the previous 3.8 billion years of life on planet Earth.

NOTES

1. *Gyn* is the Greek prefix root of the word female, as in the English *gynecology*.

2. Glynn Isaac, quoted in Steven Mithin, *The Prehistory of the Mind* (London: Thames and Hudson, 1996), p. 123.

3. Derek Bickerton, *Language and Human Behavior* (Seattle: University of Washington Press, 1995), p. 65.

Leonard Shlain is the author of three critically acclaimed, national best-sellers: *Art & Physics: Parallel Visions in Space, Time & Light* (HarperCollins), *The Alphabet Versus the Goddess: The Conflict Between Word and Image* (Viking/Penguin), and *Sex, Time and Power: How Women's Sexuality Shaped Human Evolution* (Viking/Penguin). This essay is an extremely condensed version of the ideas that he put forth in *Sex, Time and Power*, recently the winner of the Quality Paperback Book Award for the best nonfiction in its category. The author would appreciate hearing from readers through his email: Lshlain@aol.com.

Finding Balance

Thucydides wrote in his history of the Peloponnesian War that nations are moved to war for one of three reasons: "honor, fear, and political interest." Certainly we could to this day agree with that, except I would make one change in that statement. I would remove the word "nations" and insert the word "men." I think it fair to say that no matter the century the pattern has not changed: if you made a list of the most despicable one thousand characters of the twentieth century, they would all be men. It was men who robbed, raped, pillaged, plundered, burned, and bombed their way through history, ancient as well as modern. The destructiveness of men is applicable to this exhibition because, as curator, I am operating under the premise that the imbalance of patriarchal dominance over the matriarchal has reached a dead end, with no way of turning back.

It is no small task to start with such a premise and then go about convincing an audience that the time of male/female balance is here. I do maintain a belief in that balance as a grand premise and that the world at large is ready for such a paradigm shift. There exists in any time period what is referred to as the "spirit of the age." It is my belief that finding this balance between the two "halves" of our humanity is upon us and is part of the spirit of our age.

I would like to introduce the artists in this exhibition in thematic order. I start with Brad Miller, who in 1983 made a sculpture from clay, titled *Holding* (pp. 50–51), which reaches as deep back into our beginnings as any piece of art I know. *Holding* is a handheld, bread dough-size chunk of kneaded clay with striations of mixed earth components. This piece of art has at its core a hollowed out form, one reflecting the very hand that first scooped out a dish. It reflects the shape of the form that gave us art at its starting point. That starting point came when a woman picked up a round bulbous stone in the riverbed and held it in her hand, turning it in awe as she saw in it the life that moves within herself. The stone thus imbued now carried with it the symbol that would be art. This "Lucy" of art gave us something else in this transformation of meaning to object, a molecule of what was to come in the thousands of years down the road: science and philosophy.

Fig. 9
BRAD MILLER
Maybe, 2005
Mixed media on wood
60 x 48 x 1 inches
Courtesy of the artist

Now fast-forward through time and look at the three clay boat forms by Barbara Sorensen, *Boat I–III* (2006, pp. 52–55). How close to our inner being is the vessel in art? And when confronted with these images, do we find they give rise to this inner history? The surfaces of these are as the plowed earth, furrows seen from great distances, covered in stones and tracks of all nature. The insides of these forms are dark and undulating, like the host of water snakes that were blessed by the mariner who, by the very act of giving them a certain reverence, was freed. Can by nature a free soul fly or swim or sail in one's thoughts? How else is art of symbolic reference conjured?

Look at the work of Charmaine Locke, whose sculpture *Open Book* (2004, pp. 62–63) holds that which feeds the soul. Locke asks the question, "Why can't we find the path to peace when it is right in front of our eyes?" I contend the path lies in the finding of male/female balance. *Open Book* is a female figure with multiple arms offering humanity metaphoric gifts for the taking: an egg carrying the content of the imbued stone, a ring giving us the sense of completion, a flower in full bloom, and a bowl, a fish, and a book. All these symbols are foodstuffs for the soul offered by a giver of life, a giver asking only for understanding. This figure is representative of what holds the center ground of our sociological being.

Picture a dying warrior being held in the arms of the giver as he says, "All I ever really wanted was to go home with you." This has been repeated over and over as a literary and art historical image since our beginning. Why can he not attain a balanced path when it is right in front of his eyes? Does the path exist only in his dreams? Who among us has found the way home to safety in the here and now? Do the sharp edges of broken rocks fit the feet that make the marks? A second work by Locke, a large black and white painting called *Night Wonder* (2005, fig. 1), depicts the dream at its best. It is in wonderment that we stand in the midst of the night sky and conjure that which fills our inner needs.

Or is the journey and the search all we get? Joseph Campbell said that "pain is the price of life," the markers of our journey. I would add that balance gives us the understanding to read the markers. A third piece by Locke is called *Journey* (2006, pp. 58–61), comparable to a work by Jody Guralnick called *At the Table* (2005, pp. 76–77), both sculptures showing the multilayered history of our journey through life. This journey is thousands of years old and has its origins in the imbuing of the stone and the cupping of the clay. In these works lie the fragments of old moments gone forever, each complete in their message to the viewer. In *Journey* Locke has given us a map, with signs and clues as to our maneuverability on the path, showing the dichotomy of transition and stasis by giving evidence of spots of time that are fixed and available; through these images she is letting us know of the pain and glory of being alive. In *At the Table* Guralnick has taken forms from the hearth—plates, bowls, cups, pitchers, and platters—and layered them within strings of color and surface imagery, one atop the other, again and again, until we see a whole emerge before us. These utilitarian forms are familiar to the eye, and at first glance so too seems the painted surface, but on a closer examination, the surface gives forth meanings other than mere decoration. The deeper we look, the more viscous and virus-like the surface forms become in color and shape, and the more we realize that strength and power in the most hurtful of terms sometimes lie below the surface.

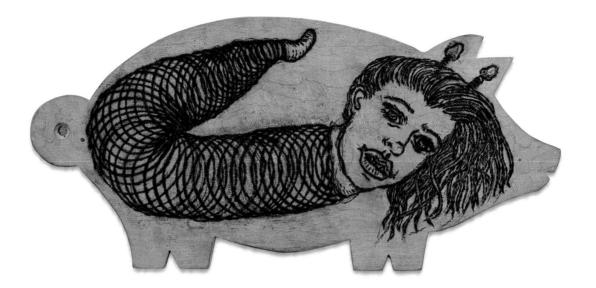

Fig. 10
PAMELA JOSEPH
Insatiable Slinky (from *The Hundred Headless Women* series), 2006
Wooden kitchen cutting board
8¼ x 17¾ x ⅝ inches
Courtesy of the artist

Picture looking at Guralnick's table with a window behind it. Out of the window you see limbs washed over with different hues of blues and reds, and leaves offering sanctuary to birds, all taking care to build well their future. They string together nests with vines and threads that hold a precarious system of order. Does such activity represent something outside the human realm? Have we as earth's great thinkers closed the door on a natural balance that we seek and need on our own?

What price is paid in the unbalanced world, and who pays it? This is a fair question and one that Pamela Joseph asks repeatedly in her sculptural wall relief called *The Hundred Headless Women* (2001–2006, pp. 64–67). This work of art uses cutting boards from the kitchen on which we cut that which has come from the warmth of the hearth. But from that point forward, the sociology of the moment takes a turn to yet another familiar territory that has been the nature of the beast for a long time, a place of sacrilege and associations made at a degrading level. In *Insatiable Slinky* (2006, fig. 10), the one who bakes the bread now lies on the cutting board in the form of a slinky with the head of a woman and the tail of a snake, burned in pictured form on a pig-shaped wooden cutting board. On another pig-shaped cutting board in a work called *Self Serving Pig (Head on a Platter)* (2001, p. 65), the woman is being made to give her own head and serve it herself. The worst of history comes to haunt us. What could speak of the imbalance in more glaring terms than the headless woman? Look closer to the core of this work of art and know it was Eve who became the juggler in a three-ring circus, firing ovens and wearing steel underwear, while armored men were out conquering nature or just killing something. What price is paid and who pays it? History gives the answer; it is time to understand it.

Stand close and breathe deep the air of patriarchal history that wafts in and around the soft weave and fine images in the work of Monica Chau (fig. 11 & pp. 56–57). Chau has taken ancestral tablets from a time in her own history. She has gone back several thousand years to find and read the markers recording her origins from a region in China. In these writings she sees no mention of the female lineage other than "wife of first son."

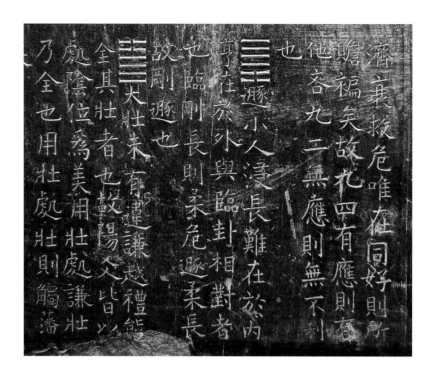

Fig. 11
MONICA CHAU
I Ching, Forest of Steles (detail), 2006
Digital dye-sublimation fabric and wood
44 x 72 inches
Courtesy of the artist

This gives us a picture that is jolting in the context of the *I Ching*, an ancient Chinese book of divination brought from the same source and written in the same time period. History does give us understanding; the question for us as a people is how to use the information given to us by the art we see.

Willard Spiegelman, a professor at Southern Methodist University, once spoke of Ezra Pound's statement "make it new," asking, "How can you make it new if you don't know what 'it' is?" Robert Creeley, the great American poet, wrote a comforting poem that states in no uncertain terms: "World's/still got/four/corners." Where better to see our personal four corners of the earth than from the center of the place that is our comfort zone, the place we call home, our bed? Brian Reid is a master craftsman, and his sculpture in this exhibition is a bed called *Hourglass* (2005, pp. 68–69). In this work of art, we see just how complex our history is. This male artist makes surfaces that are hard and polished with rigid lines leading us deep into that complexity, stating, "I have used the format of a canopy bed to separate the frame of the bed from the bed itself: the hardness of the frame from the softness of the bed, the external from the internal, the intimate from the casual, the feminine from the masculine. The sheer fabric represents the almost invisible line between these two worlds."

One of the three works I have chosen from my art is a drawing called *Together We See Worlds Apart* (2005, p. 71). In this drawing both male and female are standing on point, not on their toes but on their thumbs, for their hands are the means of supporting a fluid, never-ending body filled with black spots, each spot a pupil in the center of the eye of history. On both male and female, the hands, the bodies, and the heads all function independently, yet they meld into a single living being that reflects the other. Each is a whole, complete unto itself—not two halves making a whole, but rather two wholes giving balance to the other. There is also clarity emanating from the eyes, each seeing his and her

own world. Both are speaking from their personal rooted centers, and both are sending an equally clear voice into the space around them, yet both are being affected by the same spheres of influence. These spheres (or spots or pupils) are clear again in the second drawing called *When White Cranes Feed Around the River's Edge* (2005, p. 70), which shows the female as the river from which the wise blood flows. She then becomes the source from which the white cranes feed. Each of these elongated birds has gathered strength and a clear vision, able to see even to the molecular center of their surroundings. This is the gift the river of wise blood has to offer for those who are willing to wade and feed in her currents.

A third piece of mine in this exhibition is called *From the Heart* (1987, p. 73), which speaks of my long-held and personal interest in the idea of the female as life source. In this sculpture a tree-like figure grows out of a full and voluptuous blood-red pitcher that has been carved from a mahogany log, while from the center of this tree-like figure is growing the profile of a human. This particular human is me, for this is a self-portrait, but it is there to represent a collective, and this intent is clear in the thick red stain that is the body of the pitcher. This vessel is full with the heartbeat of human history, and since it is the seeker who finds, it is the tree roots of the seeker that draw the source ever closer to the head.

How do we move that which is deep within us from below the level of consciousness up to a place of understanding? Look at the second work of Guralnick, a painting called *Transmutation of Passion* (2002, p. 75). In this work we see again the presence of the flower in full bloom, but this lotus is dark to the eye, giving us a sense of change in the norm of its meaning. This dark flower is surrounded by a field of yellow that moves toward white orbs shadowed by orange orbs, which in turn surround the head of a figure that is said to be the Son of God. Does passion beget passion always? Is there a time for evolution as it relates to passion and thought? Can we change the pattern of deep-seated beliefs? Here we know what "it" is, so making it new is possible. Look to the organic in the other flower in this painting: a red flower coming from a red flower, yet each different in the fullness of its offering. Then compare this image, one to one, with the other works of Miller in the exhibition.

Miller's *Floats* (2005, p. 48) is a tight look at the seed core of our possibilities. I am reminded of yet another poem by Creeley, "Float not far/not up/not out/not only only," but here the referencing is parallel. Both painting and poem tell us the answers are within the mind's eye, ours to see and ours to know. Miller's painting *Maybe* (2005, fig. 9) aligns a ravine-like growth pattern along an axis where all lines lead to a crossing in the center, giving rise to questions. Is there a cross? And does this represent a belief in death and rebirth that has been symbolized by a cross for two thousand years, or are we being asked to look deeper into our personal terrain? Both may be true. The question is, what do we walk away with? Lao Tzu said some five hundred years before the cross was a symbol of anything but death: "He who knows the male, yet cleaves to what is female, becomes like a ravine, receiving all the things under heaven." The question for us in seeing the Miller painting called *Going Out* (2005, p. 49) is the same: What do we come back with? I use here yet another poem by Creeley: "So simply vast/placed/in this space/everywhere." Here both Creeley and Miller take us out to the very edge of a vast universe, then bring us home again, leaving us to ask, what do we see and what does it mean? The light layers in *Maybe* measure spaces hill to hill, while *Going Out* gives us true beauty millions of light years across.

Fig. 12
ROBERT BRINKER
The Other First Kiss (detail), 2005
Ultrachrome print
48 x 36 inches
Courtesy of the artist

What markers do we use to define the measured spaces? The photographs of Jim Baker give us pause for thought, and his picture *Geographic Marker, Black Rock Desert, Nevada* (2005, p. 86) shows the intent and reality of staking territory for our will. The intent is absolute, but the reality is ever changing. Here the stake itself has been removed from its vertical intent and laid flat with its surroundings, then washed again and again with the silt from the ravines of time, and finally removed again, leaving only the suggestion of its existence. Sun-baked and weather-worn, this impression shows how time has brought a transition, even to the point that the old belief has no bearing on the physical; now it only marks time from one belief to another. Look at the photograph called *Engineer Pass, San Juan Mountains, Colorado* (1989, p. 87) and ask of man's markers, in whose possession is this valley? Who owns the sheep that feed in the expanse before us? Do the rain, wind, and snow define the boundaries, or do the sheep? Man's struggle for dominion exists in the trails he has cut in the earth to get his sheep to abide by and obey his rule of ownership, saying "this belongs to me" and "it is mine."

I turn now to the lenticular photographs of Linda Girvin, whose two pieces are powerful reminders of the historical context of the subject of this exhibition. Girvin's *Tight Pull* (2006, p. 79) gives us a look deep into the subconscious of the female psyche, where holding on tight is a means of survival. In this work she depicts herself as Everywoman trying to function in fields of moving circular planes, all taking her further away from a stable and upright and balanced position—that of being whole and equal. She struggles in a world where order is maintained by some means other than those which she has in her control. These lavender circular spots are not spheres in deep space, but rather flattened and drawn planes being pulled into a vortex, showing a force and power that will take all the strength her collective purpose can put forward to resist.

She appears again in *Shadowed Too* (2006, p. 81), but in this picture she stands facing a corner with no opening and no escape route. Not only is she facing uncertainty in the

search for her personal freedom, but she also has to confront a horde of skinned beasts with muscular hindquarters and no heads. There is no dialogue here, no discussion or means of conversation, just a furred flux of strained emotion. Is the orange figure a guardian of shadowed reality from outside the door of the cave wall she stares at? What do we accept as reality? Philosophers have asked that question for thousands of years. And for more years than we can count, the alpha male jumps at the crack of any snapping twig in the dark, ever intent to put someone down to restore the status quo of the patriarchal world. None of his reactions has the matriarchal in mind, only the continuation of his power, measured by his rule. Look hard at these photographs, and ask the core questions again and again.

The three ultrachrome prints by Robert Brinker take us to the here and now. Brinker has taken famous paintings and cut hieroglyphic type patterns in them, then superimposed, through these cutout slits, images of nude women from men's magazines. The first two of these three works are called *The Other First Kiss* (2005, fig. 12 & p. 83), which uses a painting by William Bouguereau, and *Duccio's Angels* (2005, p. 85), using a detail from Duccio di Buoninsegna's *Maesta* called *The Mother of God*. Here Brinker uses two female images, both reflecting the stylized view of the innocence of the Holy Mother from the nineteenth century and medieval times, respectively. Brinker then fills the picture plane with the shimmer of paradox, glistening its way to the surface and dancing across our understanding like vibrations in a filled teacup. As we scan to read the works, the multilayered imagery starts to the surface, only to be caught by reflections and dropped back to a submerged state. Is this view the view of men, and which layer more accurately applies to the reality of the male culture?

The last of Brinker's three works is *Moses* (2005, p. 84), taken from a work by Michelangelo. Certainly Moses and Michelangelo both are male, and both are at the top of the history hierarchy. In this picture Moses sits with all the physical and physiological prowess of any alpha male being propelled to the throne of power. Is this view of Michelangelo's really what Moses was, in any and all of the contexts we can place him in? Or is Brinker's view and depiction closer to the reality in man's paradoxical thinking? It is as though Brinker has captured a hard truth in the underpinnings of the male psyche and placed it just below the surface. Compare this to the female collective in Girvin's *Tight Pull* and you begin to see a deep and historic pattern that has closed off the route to freedom in Girvin's *Shadowed Too*.

I close with a photograph of Jim Baker's called *Two Years After the Fire, Yellowstone National Park, Wyoming* (1984, pp. 88–89) that shows change at its worst and best. A great fire devours the forest, leaving only a marker for a new reality that is to come and be again. If we as a society of the planet want to continue to grow and evolve, then we must embrace change as part of the function of the very nature that makes us human. It is to be frozen in time to say creation "was." Rather I would say creation "is," and with that in mind, I would say creation is not over and we as part of the process of creation are evolving. This would then lead me to believe that creation and evolution are one and the same. If so, I would go back to Charmaine Locke's question: "Why can't we find the path to peace when it is right in front of our eyes?"

WORKS IN THE EXHIBITION

BRAD MILLER

BRAD MILLER
Floats, 2005
Mixed media on wood
60 x 48 x 1 inches
Courtesy of the artist

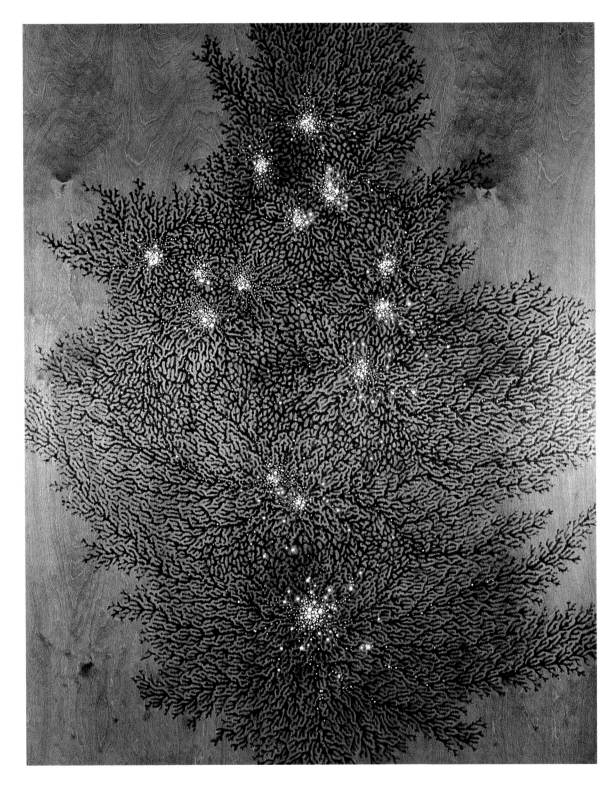

BRAD MILLER
Going Out, 2005
Mixed media on wood
60 x 48 x 1 inches
Courtesy of the artist

BRAD MILLER
Holding, 1983 (above, detail, and opposite)
Lustered stoneware
4$^1$/4 x 10$^1$/2 x 12 inches
Courtesy of the artist

BARBARA SORENSEN

BARBARA SORENSEN
Boat I–III, 2006
Stoneware and stones
18 x 44¹/2 x 19; 13 x 46 x 14;
and 13¹/2 x 46 x 17 inches, respectively
Courtesy of the artist

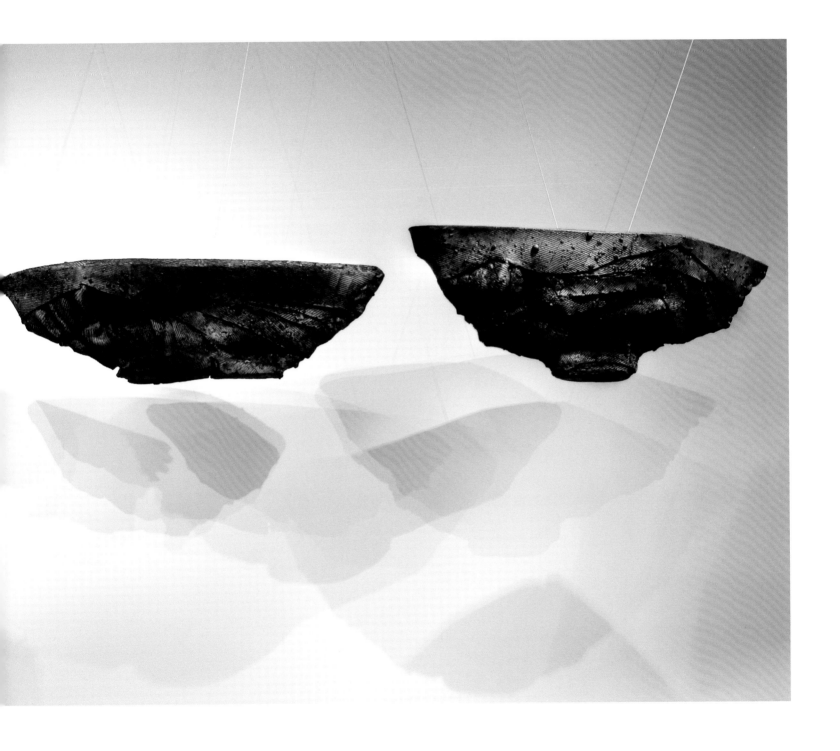

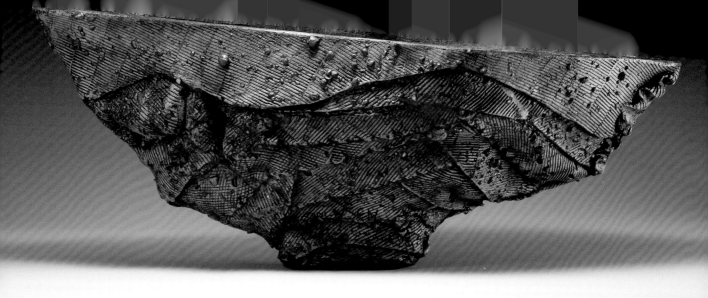

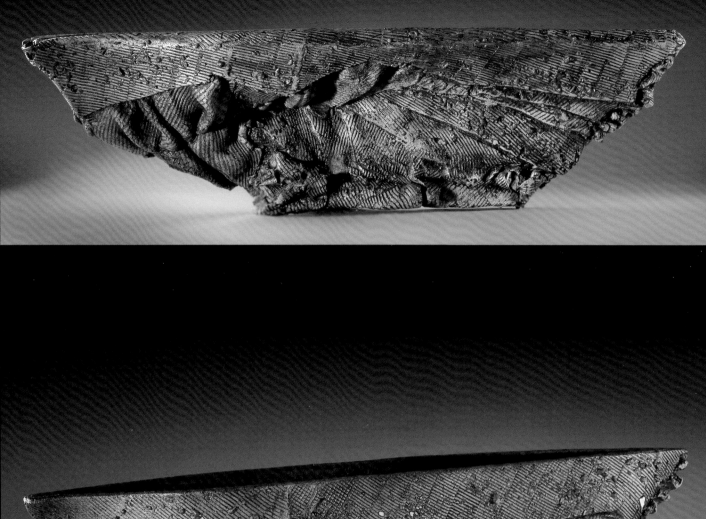
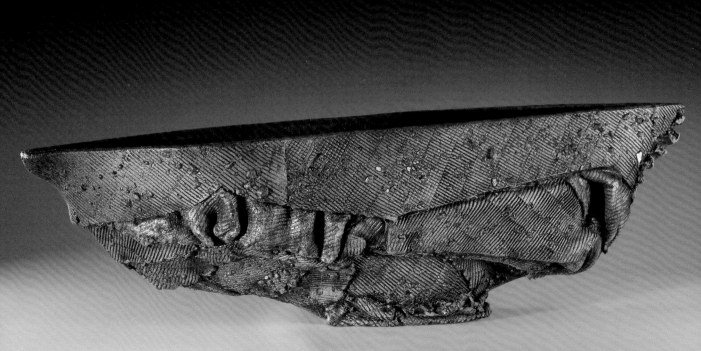

MONICA CHAU

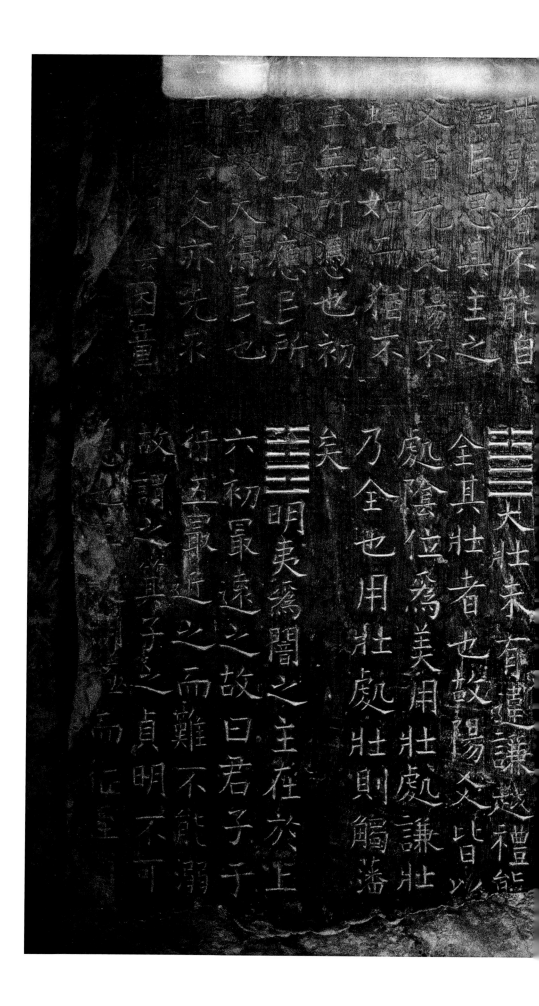

MONICA CHAU
I Ching, Forest of Steles, 2006
Digital dye-sublimation fabric and wood
44 x 72 inches
Courtesy of the artist

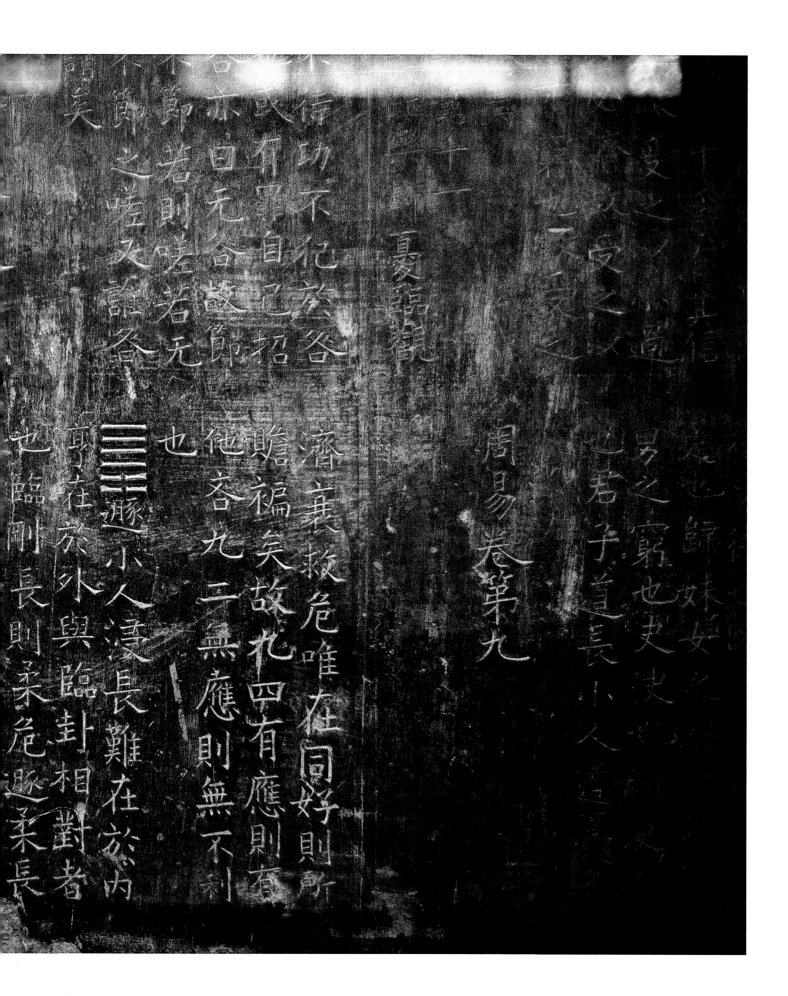

周易卷第九

夏錫疇

君子道長小人道憂也

臨剛長則柔危遯柔長也哥在於外與臨封相對者遯小人凌長難在於內也

他吝九二无應則無不利臨福矣故九四有應則有濟衆救危唯在同好則所

停功不犯於咎自己招他節式有罪自己招不白无咎故節節若則无節之嗟又誰咎矣

CHARMAINE LOCKE

CHARMAINE LOCKE
Journey, 2006
Mixed media
10 x 108 x 72 inches
Courtesy of the artist

CHARMAINE LOCKE
Journey (details), 2006
Mixed media
10 x 108 x 72 inches overall
Courtesy of the artist

Healing

Fear

Ignorance

CHARMAINE LOCKE
Open Book, AP, 2004–2005
(installation view, Carbondale, Colorado)
Bronze
79 x 63 x 40 inches
Courtesy of the artist

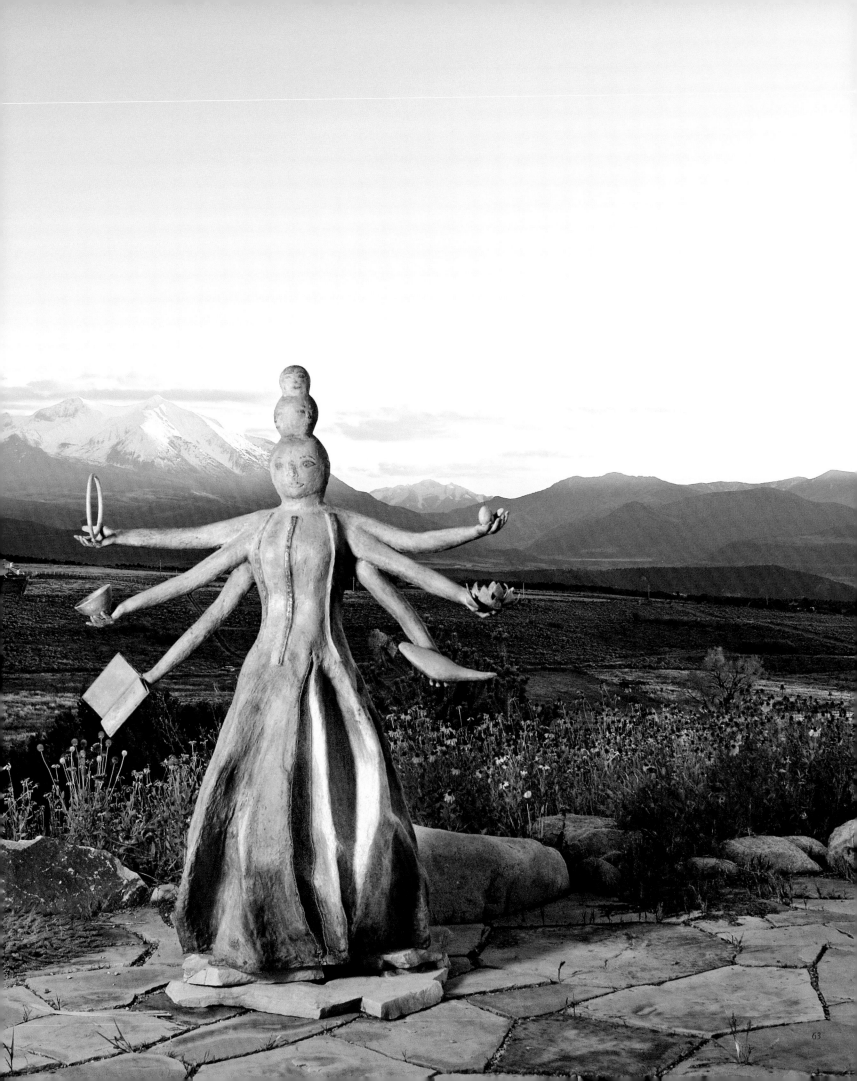

PAMELA JOSEPH

PAMELA JOSEPH
(from *The Hundred Headless Women* series)

Pulling in the Reins, 2001
Wooden kitchen cutting board
13$^{1}/_{2}$ x 9$^{1}/_{4}$ x 1 inches
Courtesy of the artist

The Headless Woman, 2001
Wooden kitchen cutting board
11$^{3}/_{4}$ x 18 x 1$^{1}/_{4}$ inches
Courtesy of the artist

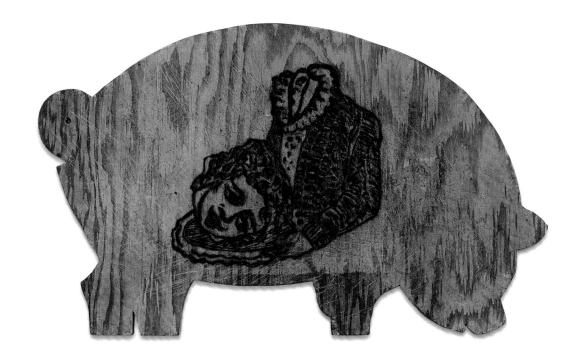

PAMELA JOSEPH
(from *The Hundred Headless Women* series)

Self Serving Pig, 2001
Wooden kitchen cutting board
10¹/4 x 17¹/2 x ¹/2 inches
Courtesy of the artist

Ankle Weights, 2001
Wooden kitchen cutting board
15¹/2 x 11³/4 x 1 inches
Courtesy of the artist

pages 66–67:
The Hundred Headless Women, 2001–2006
Seventy-seven wooden kitchen cutting boards
96 x 180 inches overall
Courtesy of the artist

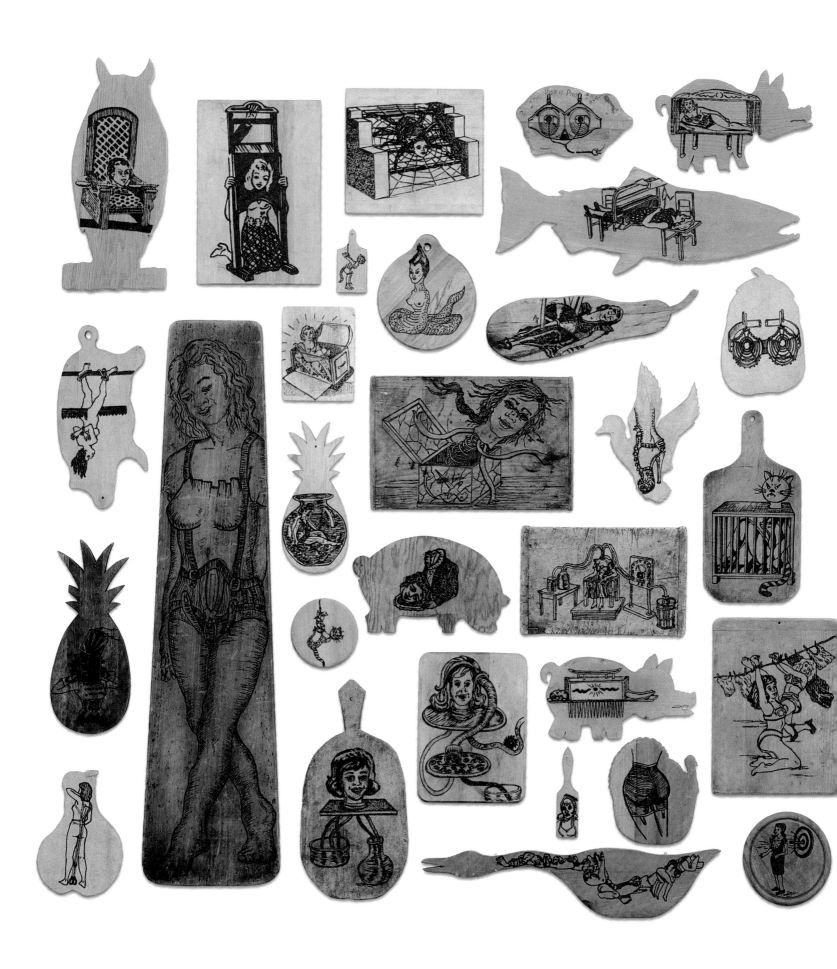

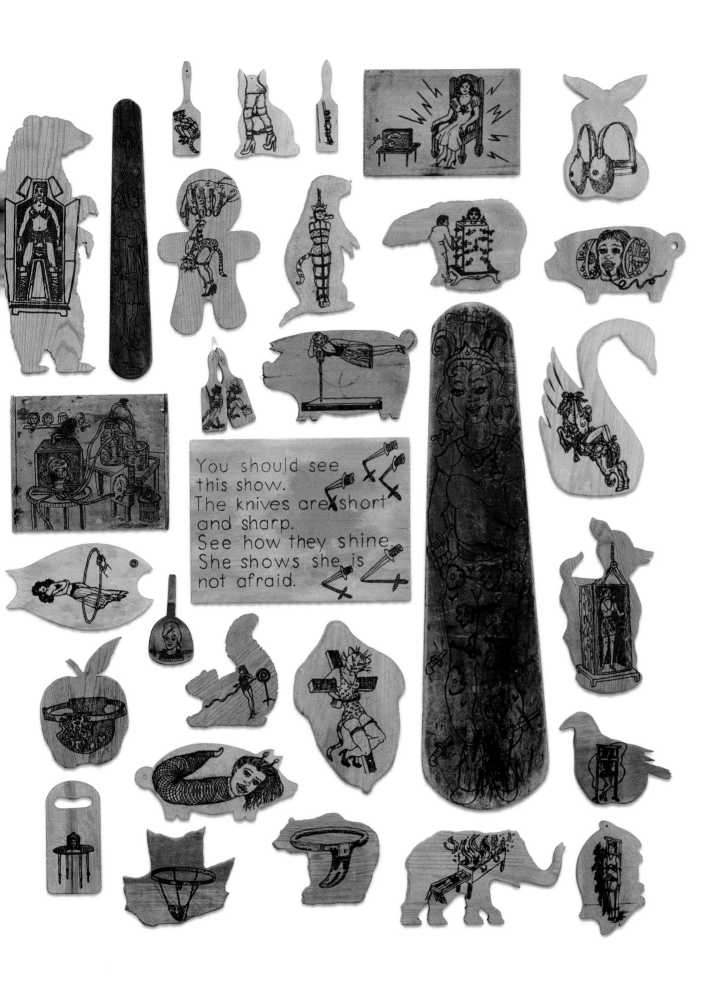

You should see
this show.
The knives are short
and sharp.
See how they shine.
She shows she is
not afraid.

BRIAN REID

BRIAN REID
Hourglass, 2005
(above, details of canopy interior and parquetry, and opposite, installation view)
Bed of iron-stained mahogany, various veneers, quilt, and cotton
76 x 76 x 96 inches
Courtesy of the artist

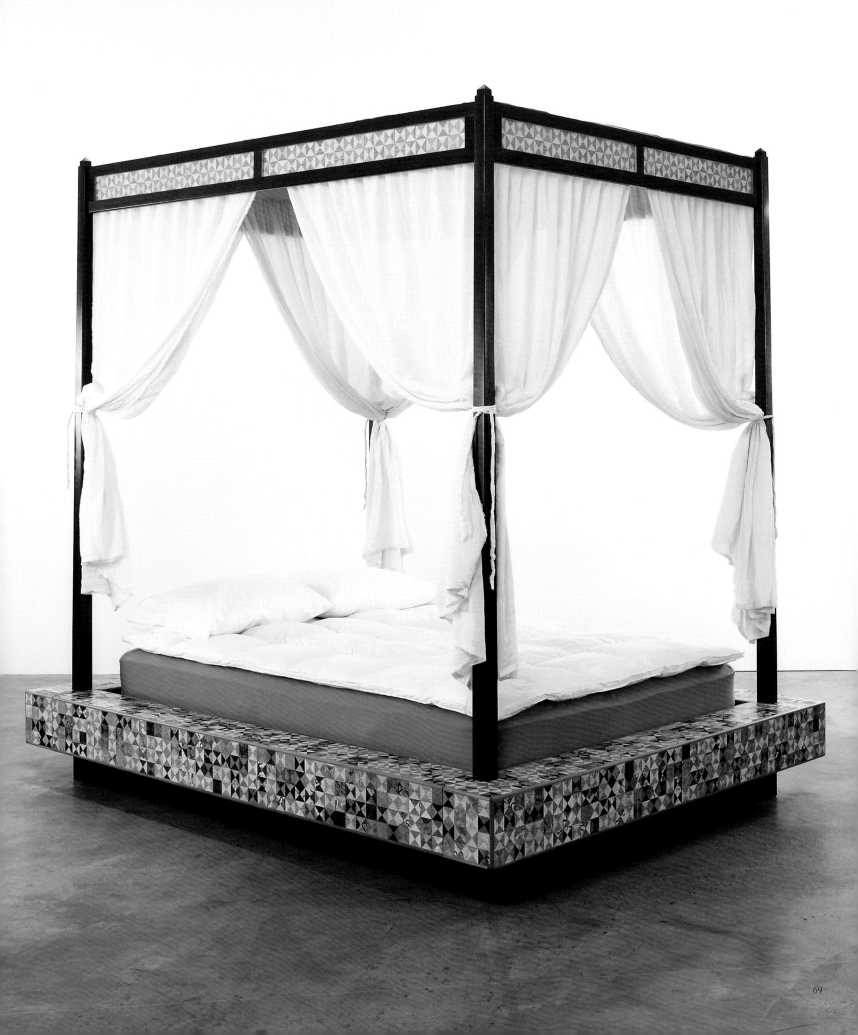

JAMES SURLS
When White Cranes Feed Around the River's Edge, 2005
Graphite on four-ply paper
40 x 60 inches
Courtesy of the artist

Together We See
Worlds Apart.
James Surls
2005

JAMES SURLS

Together We See Worlds Apart, 2005
Graphite on four-ply paper
40 x 32 inches
Courtesy of the artist

JAMES SURLS
From the Heart, 1987
Mahogany, oak, and steel
98 x 40 x 51 inches
Courtesy of the artist

JODY GURALNICK

JODY GURALNICK
Transmutation of Passion, *2002*
Oil and collage on wood
72 x 72 inches
Collection of Charmaine Locke

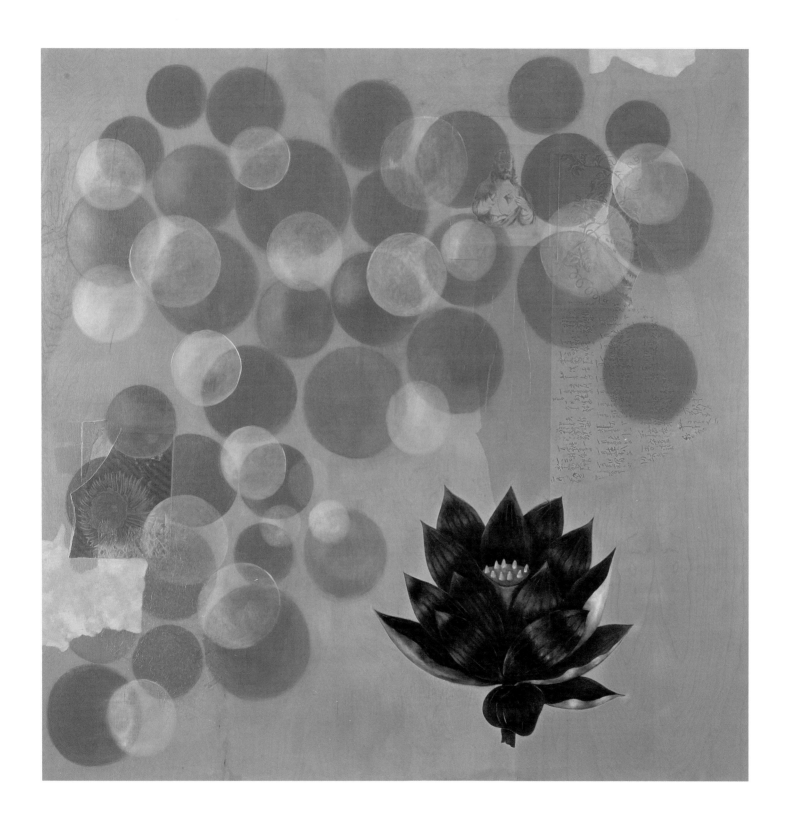

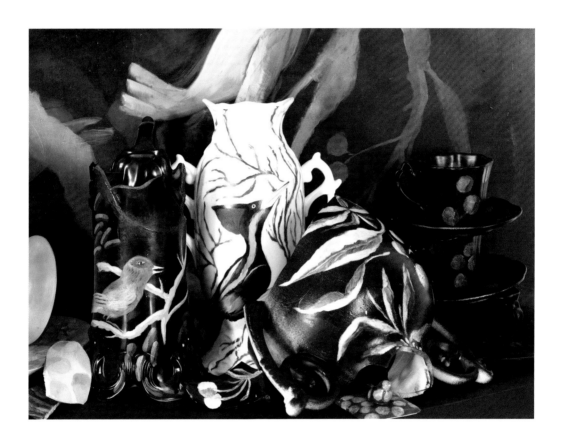

JODY GURALNICK
At the Table (above, detail, and opposite), 2005
Encaustic and collage on wood with ceramic pieces
48 x 60 inches; shelf: 18 x 77 inches
Courtesy of the artist

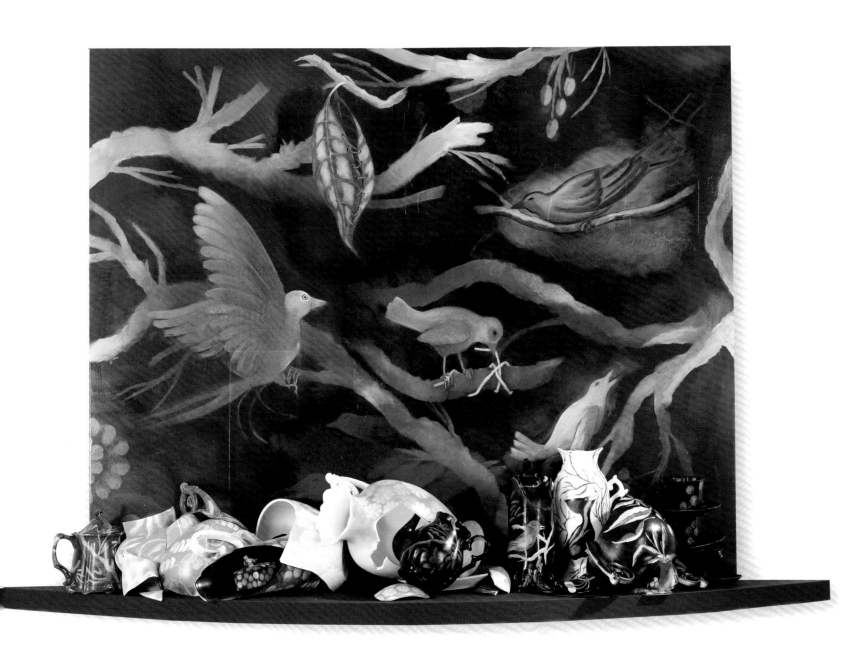

LINDA GIRVIN

LINDA GIRVIN
Tight Pull, 2006
3-D lenticular photograph
61 x 42 inches
Courtesy of the artist

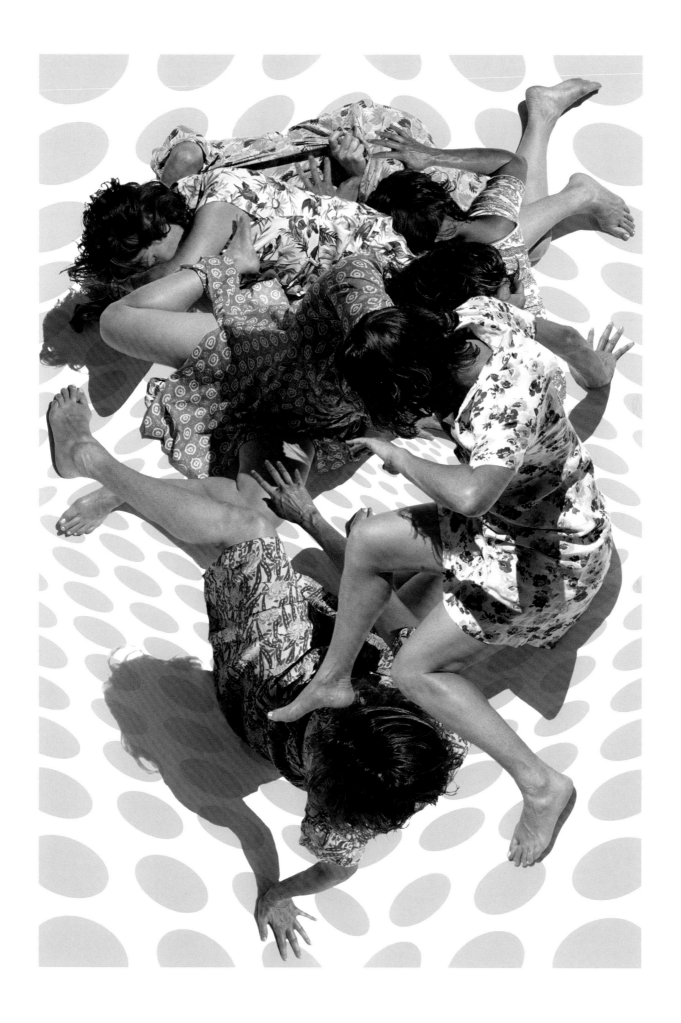

LINDA GIRVIN
Shadowed Too, 2006
3-D lenticular photograph
61 x 42 inches
Courtesy of the artist

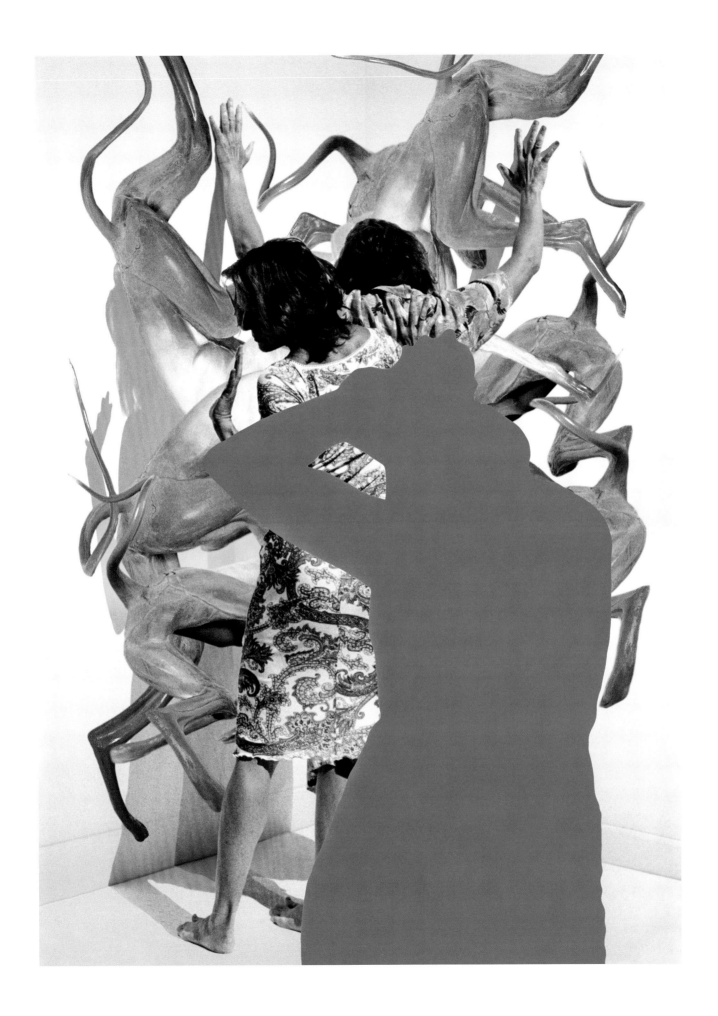

ROBERT BRINKER

ROBERT BRINKER
The Other First Kiss, 2005
Ultrachrome print
48 x 36 inches
Courtesy of the artist

ROBERT BRINKER
Moses, 2005
Ultrachrome print
48 x 36 inches
Courtesy of the artist

ROBERT BRINKER
Duccio's Angels, 2005
Ultrachrome print
40 x 36 inches
Courtesy of the artist

JIM BAKER
Geographic Marker, Black Rock Desert, Nevada, 2005
Photographic print
30 x 24 inches, AP 2/3
Courtesy of the artist

JIM BAKER
Engineer Pass, San Juan Mountains, Colorado, 1989
Photographic print
30 x 38 inches, AP 2/3
Courtesy of the artist

JIM BAKER
Two Years After the Fire, Yellowstone National Park, Wyoming, 1984
Photographic Print
20 x 25 inches, AP 1/3
Courtesy of the artist

Catalogue of the Exhibition

JIM BAKER
Two Years After the Fire, Yellowstone National Park, Wyoming, 1984
Photographic print
20 x 25 inches, AP 1/3
Courtesy of the artist

Engineer Pass, San Juan Mountains, Colorado, 1989
Photographic print
30 x 38 inches, AP 2/3
Courtesy of the artist

Geographic Marker, Black Rock Desert, Nevada, 2005
Photographic print
30 x 24 inches, AP 2/3
Courtesy of the artist

ROBERT BRINKER
Duccio's Angels, 2005
Ultrachrome print
40 x 36 inches
Courtesy of the artist

Moses, 2005
Ultrachrome print
48 x 36 inches
Courtesy of the artist

The Other First Kiss, 2005
Ultrachrome print
48 x 36 inches
Courtesy of the artist

MONICA CHAU
I Ching, Forest of Steles, 2006
Digital dye-sublimation fabric and wood
44 x 72 inches
Courtesy of the artist

LINDA GIRVIN
Shadowed Too, 2006
3-D lenticular photograph
61 x 42 inches
Courtesy of the artist

Tight Pull, 2006
3-D lenticular photograph
61 x 42 inches
Courtesy of the artist

JODY GURALNICK
Transmutation of Passion, 2002
Oil and collage on wood
72 x 72 inches
Collection of Charmaine Locke

At the Table, 2005
Encaustic and collage on wood with ceramic pieces
48 x 60 inches; shelf: 18 x 77 inches
Courtesy of the artist

PAMELA JOSEPH
The Hundred Headless Women series, 2001–2006
Wooden kitchen cutting boards
Individual dimensions vary, 96 x 180 inches overall
Courtesy of the artist

CHARMAINE LOCKE
Open Book, 2004
Bronze
79 x 63 x 40 inches, AP
Courtesy of the artist

Night Wonder, 2005
Plaster and shoe polish
92 x 48 inches
Courtesy of the artist

Journey, 2006
Mixed media
12 x 108 x 72 inches
Courtesy of the artist

BRAD MILLER
Holding, 1983
Lustered stoneware
4$^{1}$/4 x 10$^{1}$/2 x 12 inches
Courtesy of the artist

Floats, 2005
Mixed media on wood
60 x 48 x 1 inches
Courtesy of the artist

Maybe, 2005
Mixed media on wood
60 x 48 x 1 inches
Courtesy of the artist

Going Out, 2005
Mixed media on wood
60 x 48 x 1 inches
Courtesy of the artist

BRIAN REID
Hourglass, 2005
Bed of iron-stained mahogany, various veneers, quilt, and cotton
76 x 76 x 96 inches
Courtesy of the artist

BARBARA SORENSEN
Boat I, 2006
Stoneware and stones
18 x 44$^{1}$/2 x 19 inches
Courtesy of the artist

Boat II, 2006
Stoneware and stones
13 x 46 x 14 inches
Courtesy of the artist

Boat III, 2006
Stoneware and stones
13$^{1}$/2 x 46 x 17 inches
Courtesy of the artist

JAMES SURLS
From the Heart, 1987
Mahogany, oak, and steel
98 x 40 x 51 inches
Courtesy of the artist

Together We See Worlds Apart, 2005
Graphite on four-ply paper
40 x 32 inches
Courtesy of the artist

When White Cranes Feed Around the River's Edge, 2005
Graphite on four-ply paper
40 x 60 inches
Courtesy of the artist

Jim Baker

I was the executive director of Anderson Ranch Arts Center in Snowmass Village, Colorado, from 1995 to 2006. I recently accepted the position of the president of Maine College of Art in Portland, Maine.

In 1973, I received an undergraduate degree in meteorology from The Pennsylvania State University and later earned an M.F.A. in photography from the Rhode Island School of Design.

I served as an assistant professor of art from 1975 to 1981 at Edinboro State University in Pennsylvania and as an associate professor of arts and humanities at The University of Texas at Dallas until 1986. In that year, I accepted the position of artist-in-residence and program director for photography and digital imaging at Anderson Ranch.

I produced the touring exhibition "Photography: The Selected Image" with Gerald Lang in 1976–77 and various symposia, including "The Political Landscape" with Richard Misrach in 1989 and "Art into Action: Public Art for People" with Arlene Raven in 1994.

I have exhibited my landscape photographs throughout the United States and am represented in several private and museum collections. In 1988, I received an Individual Artist's Fellowship from the Colorado Council on the Arts. I have also served as a juror for the council. I contributed an essay for the book *Listen To The Trees* by John Sexton (Bulfinch, 1994) and have written on the arts for national publications such as *Outside Magazine*.

Nationally, I have served on the board of the Society for Photographic Education and as chair of the board of the Alliance of Artist Communities. In Snowmass Village, I served as chair of the Arts Advisory Board and as a member of the town council's Leadership Forum. I served on the board of the Aspen/Snowmass Council for the Arts and as the cultural non-profit representative and chair of the marketing committee for the board of the Aspen Chamber Resort Association. I am a regular contributing editor to *Aspen Magazine* and for over a decade had a weekly radio interview program titled "All About the Arts" on public radio station KAJX.

Robert Brinker

I was born in Chicago in 1971. I received my B.F.A. in 1992 from the University of Illinois at Chicago. I live and work in Aspen, Colorado. I am represented in New York by Sara Tecchia Roma New York.

Some of my recent projects include a limited edition, handmade artist book, co-published with the Institute for Electronic Arts at Alfred University in Alfred, New York. I have also created a series of large-scale digital prints with Jonathan Singer at Singer Editions, Boston.

My work has appeared in many museums and institutions, including P.S.1 Contemporary Art Center, New York; the Central Academy of Fine Arts (CAFA), Beijing, China; and in Colorado at the Boulder Museum of Contemporary Art and the Aspen Art Museum. In 2003 and 2004, I was a visiting artist at the American Academy in Rome. My work is in the collections of Progressive Insurance, Altria Group Inc., and Henry Schein Inc.

Part of my background as an artist includes working as a press assistant for many fine printers, including Jack Lemon at Landfall Press, Bud Shark at Shark's Ink, and Craig O'Brien at O'Brien Graphics. I was also print shop manager at the Anderson Ranch Arts Center in 1992–93. This is where I met Peter Voulkos, the late and great clay sculptor. I worked with Pete as his exclusive printer for the last nine years of his life. We produced many unique and limited edition prints and works on paper during that period. It was an opportunity that has helped shape my work.

Monica Chau

I received my M.F.A. in photography from the California Institute of the Arts in Valencia. As an artist, I utilize digital processes and integrate mixed-media elements to create large-scale installations. My artwork has been nationally and internationally exhibited. I have been a recipient of numerous grants and awards, including a National Endowment for the Arts / Western States Arts Federation grant in photography and a Durfee Foundation grant for travel to China. My digital work is included in *An Introduction to Digital Imaging* by Joe Ciaglia (Prentice Hall, 2001). I was a Fellow in the American Photography Institute's National Graduate Seminar and a Curatorial Fellow in the Whitney Museum of American Art's Independent Study Program.

My experience teaching the digital arts spans more than ten years, and I have taught at many distinguished institutions such as the University of California–Irvine, American Film Institute, University of Houston, and New York University / Tisch School of the Arts. Currently, I am a faculty member at the International Center for Photography, New York.

Linda Girvin

After earning an undergraduate degree in perceptual psychology, I took an unforeseen life turn—a strong interest in art-making that led in 1978 to an M.F.A. in photography from the Tyler School of Art in Philadelphia.

My approach has always been to challenge the more accepted techniques/technology of fine art photography, pushing the viewer toward a unique, more physical perceptual experience, thereby opening up new avenues for an emotionally based dialogue. Currently I'm working with a lenticular, vertical lens, a technology that allows me to animate the image and/or create an illusion of three dimensions on a flat plane. Interests in the psychology of perception and contemporary dance seem to have merged in my art.

I've had numerous one-person shows around the country and am represented by galleries in Denver, Chicago, and New York. Reviews of my work have appeared in such publications as *Art in America* and *The New Yorker*. Collections and museums that have acquired my work include the Progressive Art Collection, The Israel Museum in Jerusalem, and the Norton Museum of Art in West Palm Beach, Florida, and my work is included in the U.S. State Department's Art in The Embassies Program.

I have taught various workshops around the country, and this interest in teaching led me to positions on the faculty of both Edinboro University in Pennsylvania and the University of California, Santa Barbara.

I'm pleased to be included in the Museum of Contemporary Art Denver's show "Decades of Influence: Colorado 1985–2006"—for, as a resident of Aspen, I have found the quality of light and a degree of stillness in Colorado that feeds my creative spirit.

Jody Guralnick

I live and work in Aspen, Colorado. I received my M.F.A. in painting from Pratt Institute, New York, after earning a B.A. honors degree from St. Martin School of Art in London.

My work has been exhibited nationally and internationally, and is included in the Progressive Art Collection. I received a Colorado Council for the Arts Fellowship in 1998.

In my paintings, I am drawn to the kind of symbols that emerge from our collective cultural history, elements loaded with associations. These icons have called to me since childhood, and for years I have collected the scraps that now swim beneath the surface of these paintings. They are symbols that resonate from the personal to the universal.

Pamela Joseph

I am a multimedia artist who has exhibited nationally and internationally, most recently in locations such as Paris, Barcelona, Copenhagen, and Beijing. I work and reside in Aspen, Colorado. In 2003 and 2004, I was a visiting artist at the American Academy in Rome. My work has been described as "well-executed, powerful, and edgy" by the Colorado Council on the Arts, which awarded me a Visual Arts Fellowship in 2001.

My traveling interactive installation, *The Sideshow of the Absurd*, has been exhibited at seven museums and galleries in the United States, garnering outstanding reviews and record-breaking crowds. Art writers in Florida, New Mexico, Colorado, and the Midwest have picked the show as a "favorite" exhibition, calling it "funky," "freaky," and "fascinating."

I originally created *The Hundred Headless Women* (2001–2006), an installation wall of wood-burned kitchen cutting boards, for *The Torture Museum*, a segment of *The Sideshow of the Absurd*. The images are of women in perilous and threatening situations. My creation of new wood-burned drawings has continued to the present. The title pays homage to Max Ernst's brilliant novel of collages and engravings, *The Hundred Headless Woman*. The cutting board wall is being shown in the summer of 2006 at the Museum of Contemporary Art Denver in the exhibition "Decades of Influence: Colorado 1985–2006," curated by Cydney Payton, the museum's director.

The Hundred Headless Women images are being published as a handmade book, printed in China, through the auspices of the Institute for Electronic Arts at Alfred University in Alfred, New York, and MA Nose Studios, Inc., of Aspen, Colorado. The book is dedicated to all the women throughout the world whose lowly status, appalling circumstances, and hardships are a source of pain and inspiration to me.

Charmaine Locke

My first show of small sculptures at the Max Hutchinson Gallery (1977) in Houston was followed by several "Couples" shows in Texas, Louisiana, California, and Washington, D.C. (1979–early '80s). My work has also been included in group shows in Dallas, Corpus Christi, Baltimore, New Orleans, Philadelphia, and New York.

In my travels around the United States, I became aware of many artists working with their perception of the "house." In 1979, I curated "The Image of the House in Contemporary Art" for Lawndale Art and Performance Center, Houston, producing a catalogue and a panel discussion on art, architecture, and social issues relating to shelter. Another house-themed show, "The House That Art Built" at California State University, Fullerton, included my sculptures. I would later curate another show for Lawndale, "Sculpture: The Spectrum" (1988).

My work appeared in various shows in Houston, including at Midtown Art Center, Lawndale Art and Performance Center, Glassell School of Art, Sewall Gallery at Rice University, and Graham Gallery. A solo show of my work at Graham Gallery, including an outdoor installation of hardscape, plantings, and a large outdoor sculpture, was followed by a commission for The Houston Festival and an outdoor exhibition at Connemara, Dallas. "Creative Partners" was held at Sewall Gallery in 1991.

Recent exhibitions include the creation of a large-scale collaborative sculpture (with James Surls) for Mariposa Park, Corpus Christi, Texas; "Eye to Eye: James Surls and Charmaine Locke," Art Center of Corpus Christi; and "The Creative World of James Surls and Charmaine Locke," Anderson Ranch Arts Center, Snowmass, Colorado (1999).

I also created and produced the multimedia performance "Songs of Experience" (1994–95).

In 2004 the City of Corpus Christi commissioned the outdoor bronze sculpture *Open Book*, Dedicated Copy.

I served as founding member and director of Amazing Space, Cleveland, Texas (1995–96), served on the board of directors of the Aspen/Snowmass Council for the Arts (1997–99), and I am currently on the board of directors for Tomorrow's Voices, Carbondale, Colorado.

Brad Miller

As I was born and raised in the Pacific Northwest, my early encounters with art took place in the museums of Portland and Seattle. Their meager holdings of contemporary and European art were offset by major displays of Asian and Pacific Northwest Native American art. These elegant nature-based images were most often decorated with universal patterns and symbols shared throughout the Pacific Rim. This work informed my earliest attempts at making art and are at the core of what I am still exploring today at the age of 55.

My most recent works include photograms of water and ice, burned dendritic patterning drawn on large sheets of wood, and ceramic bowls heavily carved and worked with close-packing patterns.

Recent works have landed in several museums including the Museum of Fine Arts, Houston, the Los Angeles County Museum of Art, and the Denver Art Museum. An extensive survey of my work can be seen at bradmillerstudio.com.

Brian Reid

I am a studio furniture designer based on the mid-coast of Maine. In 1993, following ten years of working as a mechanical engineer in my hometown of Seattle, I decided to pursue my lifelong passion for furniture design. I was accepted into Parnham College in England, studying with founders John Makepeace and Robert Ingham. I am an honors graduate and the fifth of only eight Americans to attend this distinguished program. I have been an artist-in-residence at Anderson Ranch Arts Center, Snowmass Village, Colorado, and recently completed a fellowship at the Center for Furniture Craftsmanship in Rockport, Maine.

As a designer, I have worked in a variety of styles, from postmodern to post-rustic. I am currently exploring traditional forms, such as the Queen Anne highboy and American game table, that display my unique technique of pattern marquetry. My furniture pieces based on the applied decoration of traditional quilt patterns are currently on view at the Messler Gallery, Rockport, Maine.

Barbara Sorensen

I am a sculptor and printmaker who is interested in the landscape and the figure, and in how these relate to each other in the environment. I use highly textured surfaces in both my large-scale totems and my smaller vessel-referenced works. These environmental installations, originally created in clay, are now often cast in bronze or resins. My boat series is a metaphor for the body—containers of our souls juxtaposing the external and internal, masculine and feminine.

After graduating from the University of Wisconsin and pursuing an art teaching career, I returned to the studio as a full-time artist, working in both Winter Park, Florida, and Snowmass Village, Colorado.

My work is exhibited and collected in museums, galleries, and public and private spaces across the country. Some of the permanent public sculpture exhibitions showing my work are in Snowmass, Colorado, and at the University of Central Florida in Orlando. My most recent shows include a one-person exhibition of sculpture featuring eighty-five works at Leu Gardens in Orlando, Florida, and an installation exhibition at the Duval Smart Gallery in Aspen, Colorado. My work is also in numerous museum collections including those of the Orlando Museum of Art, Florida; Everson Museum, Syracuse, New York; and Newark Museum, New Jersey.

Many national publications have featured my work. Most recently, my art has appeared on the covers of Janet Mansfield's book *Ceramics in the Environment* (A and C Black, 2006) and Peter King's book *Architectural Ceramics for the Studio Potter* (Lark Books, 1999), accompanied by feature articles in both books.

James Surls

I was born in East Texas in 1943 and graduated from Sam Houston State Teachers College in 1965 and from Cranbrook Academy of Art in 1968. I taught at Southern Methodist University in Dallas from 1969 until 1976, and then moved to Splendora, Texas, with the love of my life. Charmaine and I lived there for a little over twenty years, experiencing every emotion that a couple with kids, growing together and as individuals, can endure. We have lived in the Roaring Fork Valley of Colorado for the past nine years, and love it for a fact.

Along the road I made art and curated shows with the ferocity of a man possessed. Over the years, I have been represented by four different galleries in New York, the last of which I like the best, and that is the Charles Cowles Gallery. I hope to show with Charley for a long time; he is a kind and generous man. I also show with the Barbara Davis Gallery in Houston, and the Gerald Peters Gallery in Santa Fe and Dallas, and I have a good working relationship with all of them.

I think my proudest accomplishment is that I still love my wife and have seven beautiful daughters who are independent and capable individuals. The next proudest thing is being collected by all those museums around the country and having my work appear in all the solo shows and group shows. There have been so many, it is hard to keep count. But I would like to mention three in particular. The first is an exhibition called "Visions" (1984) at the Dallas Museum of Art, accompanied by a book called *Visions: James Surls, 1974–1984*. Next is a 2003 show and catalogue at the Meadows Museum in Dallas, "James Surls—In the Meadows and Beyond." Last is the Blaffer Gallery in Houston that presented "James Surls—The Splendora Years 1977–1997" with an accompanying catalogue in 2005.

But at the top of my accomplishment list would have to be my involvement in the Lawndale Art and Performance Center and all those great years I spent with so many great friends. I am a lucky man.

Houston Center for Contemporary Craft

Board of Directors

Joanna Wortham, *President*

Sara S. Morgan, *Founding President*

Glen T. Eichelberger, *Vice President*

David Pesikoff, *Secretary*

Robert H. Schwartz, *Treasurer*

Richard Alvarado

Evans S. Attwell

Louise Bannigan

Angela Blanchard

Janice Rudy Falick

Lynn B. Gammon

Heidi Gerstacker

Irene Johnson

Lebeth Lammers

Ginni Mithoff

Katherine Phelps

Gerald Tobola

Staff

Kristen B. Loden, *Executive Director*

Jon Cook, *Administrative Director*

Vicki Lovin, *Development Director*

Amanda Clifford, *Exhibitions Coordinator*

Randall Dorn, *Exhibitions Assistant*

SheriAnne MacNeil, *Events Coordinator*

Amy Weber, *Education Coordinator*

Justine Welch, *Accounting Specialist*

Wanda Williams, *Retail Coordinator*

About Houston Center for Contemporary Craft

Since opening in September 2001, Houston Center for Contemporary Craft has emerged as an important cultural and artistic resource for Houston and the Southwest—one of the few venues in the country dedicated exclusively to craft at the highest level. The public response to the Craft Center's programming attests to the power of the inherent human desire to make something of beauty and lasting value.

The Craft Center's mission is to respond to that desire: *to advance education about the product, process, and history of craft*. In June 1999, the Board of Directors met for the first time. By April 2000, a site had been acquired. In November 2000, construction began. And in the fall of 2001, Houston Center for Contemporary Craft opened the doors of its 11,350-square-foot facility in Houston's vibrant Museum District. The inaugural exhibition, *Defining Craft I: Collecting for the New Millennium*, from the collection of the American Craft Museum in New York, attracted national attention and more than 1,100 visitors on the first day alone. Since that time, the Craft Center has implemented a full array of programs, the majority of which are free and open to the public.

Far more than a showcase for beautiful handmade objects, the Craft Center is a "living museum" for the dynamic process whereby imagination, skill, and knowledge are brought together in the creation of handmade objects that enrich our lives. Here, artists in residence work in five studios, refining their craft as they provide the public with an up-close look at the art of making—an experience that inspires confidence in the power of every pair of human hands. Museum-quality exhibitions capture the cultural and artistic pluralities that are the hallmarks of fine craft. A retail gallery gives visitors the opportunity to touch, admire, and buy unique pieces made by emerging and established craft artists from across the country. Educational programs offer hands-on learning experiences for all ages, and strong outreach initiatives take the craft experience into schools and neighborhood centers in some of Houston's most underserved communities. Each year, these programs link more than 30,000 individuals to their own creative capacity.

In a world driven by *bigger*, *faster*, *newer*, and *more*, the Craft Center stands as an oasis for more durable values that take their time to unfold: dedication, discipline, self-reliance, patience, appreciation, creativity, focus, skill, commitment, perseverance, originality, integrity, mastery, care, a persistent mind and an eye for beauty, and the appreciation of a job well done.

HOUSTON CENTER FOR CONTEMPORARY CRAFT

4848 Main Street, Houston, Texas 77002 • 713-529-4848

www.crafthouston.org

Photography Credits

Specific credits are listed below; all other illustrations courtesy of the respective artists

© 2006 Leo Fuchs

© 2006 Lois Greenfield, courtesy Aspen Santa Fe Ballet: fig. 6

Erich Lessing/Art Resource, NY: fig. 4

© 2006 The M.C. Escher Company-Holland: fig. 7

Brad Miller: figs. 10, 12; pp. 64, 65, 66–67, 83, 84, 85

Robert Millman: cover; frontispiece; figs. 1, 8; pp. 58–59, 60, 61, 62–63, 68, 69, 70, 71, 73, 75, 76, 77

Publication Credits

Curator and publication coordinator: James Surls

Editor: Polly Koch, Houston

Design: Don Quaintance, Public Address Design, Houston

Design/production assistant: Elizabeth Frizzell

Color separations and printing:
Dr. Cantz´sche Druckerei, Ostfildern, Germany